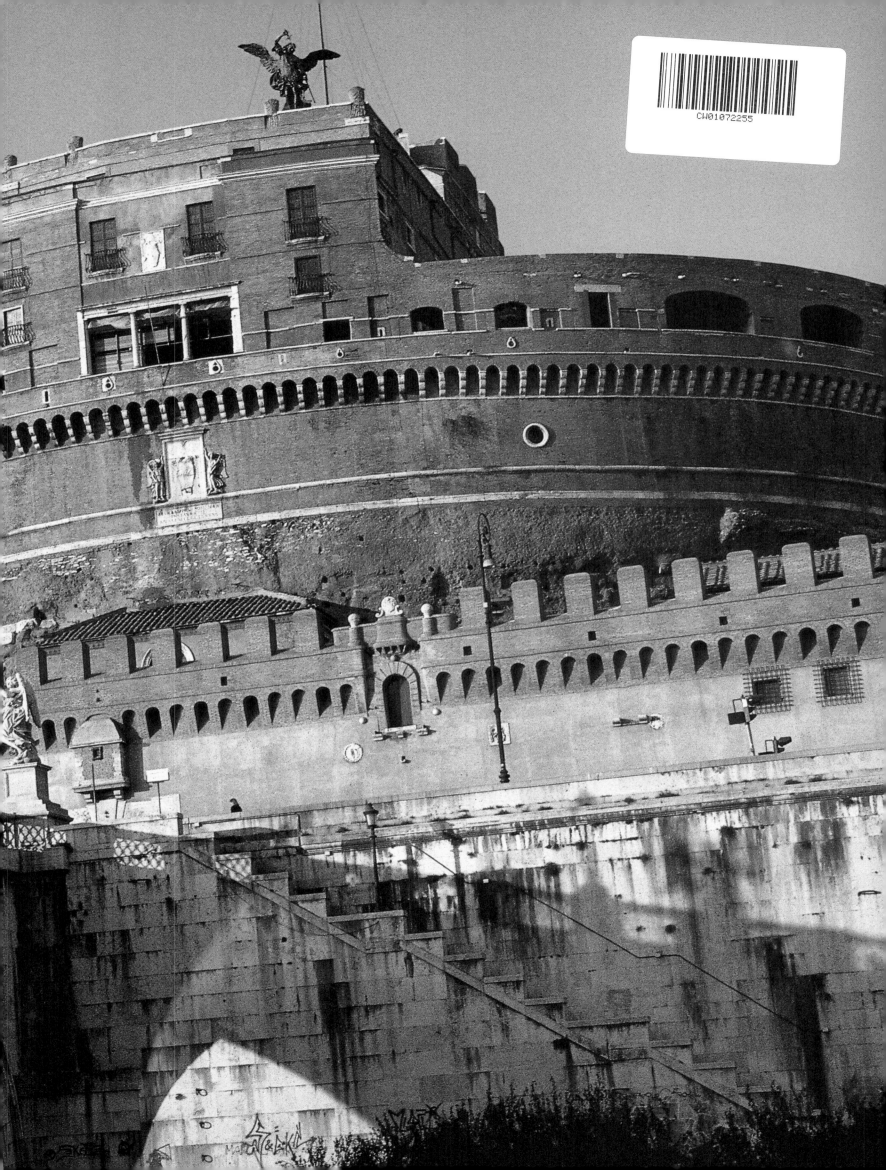

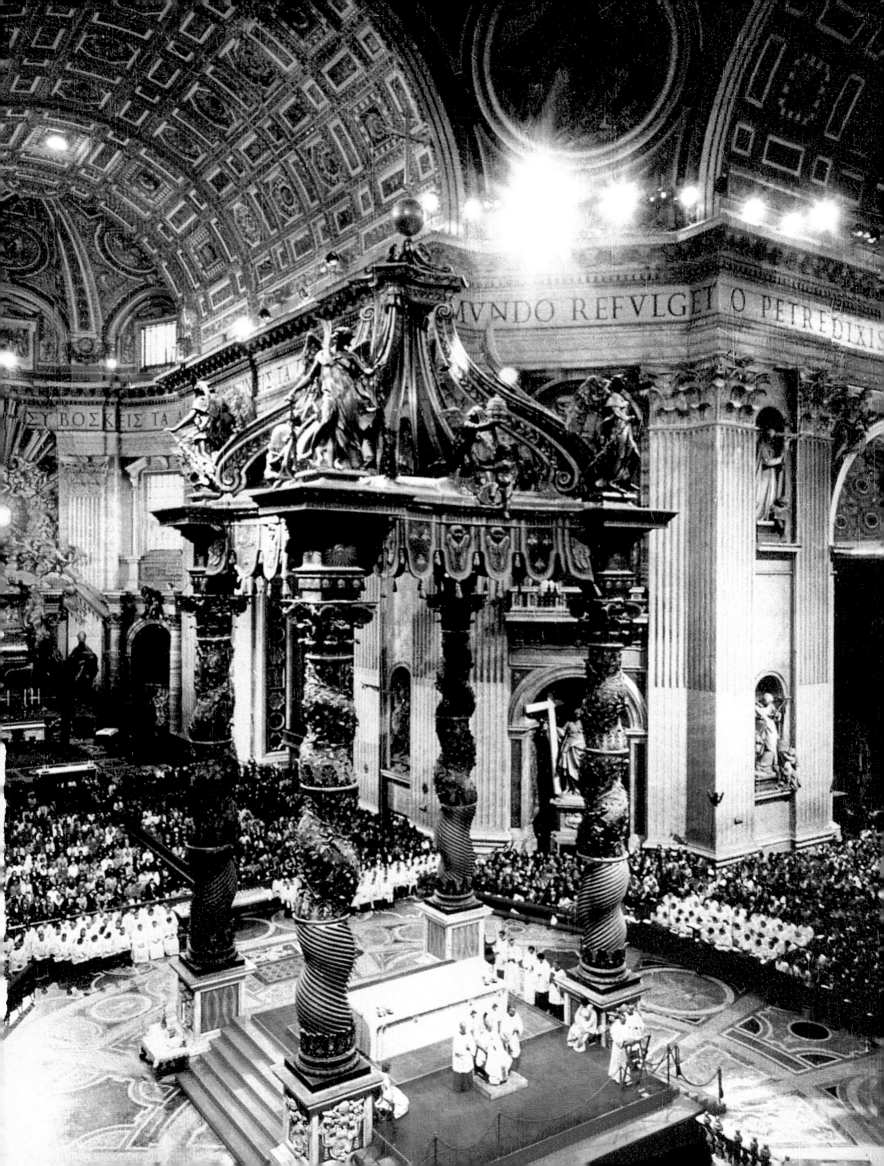

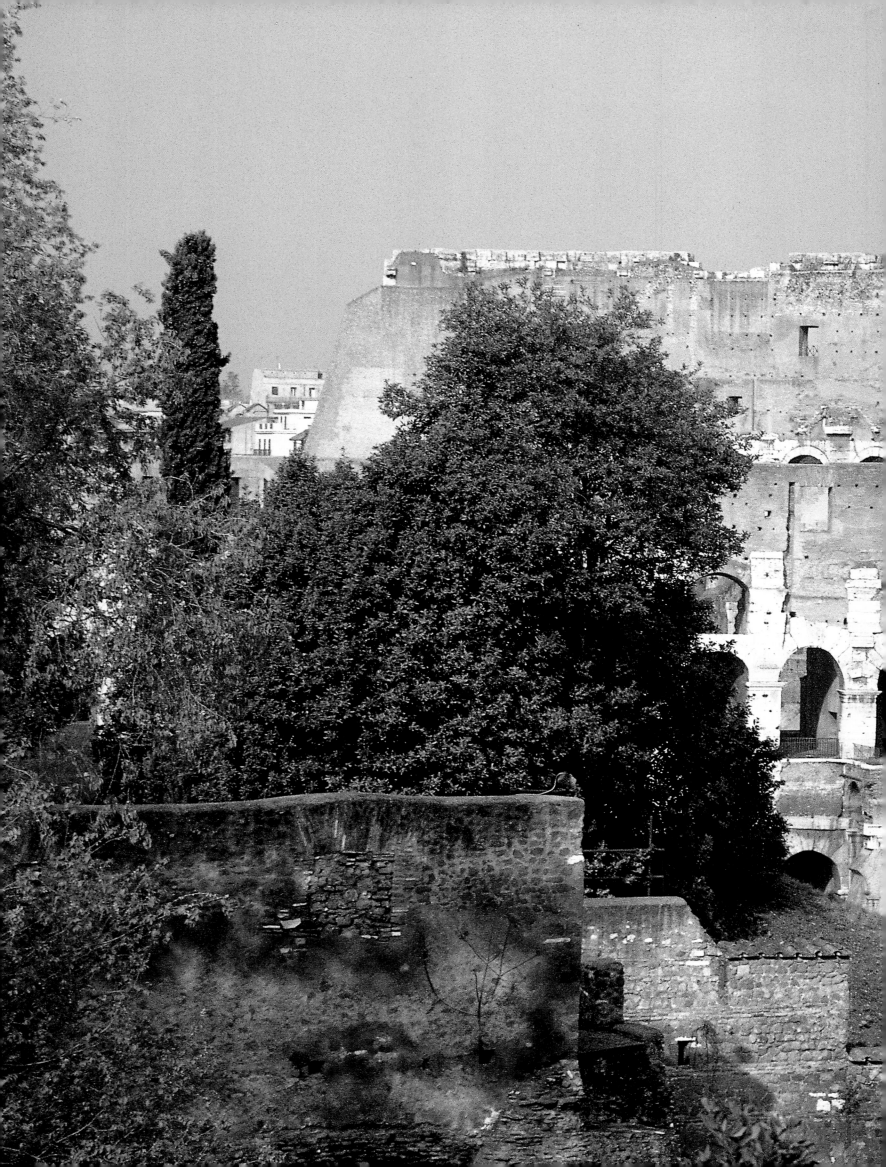

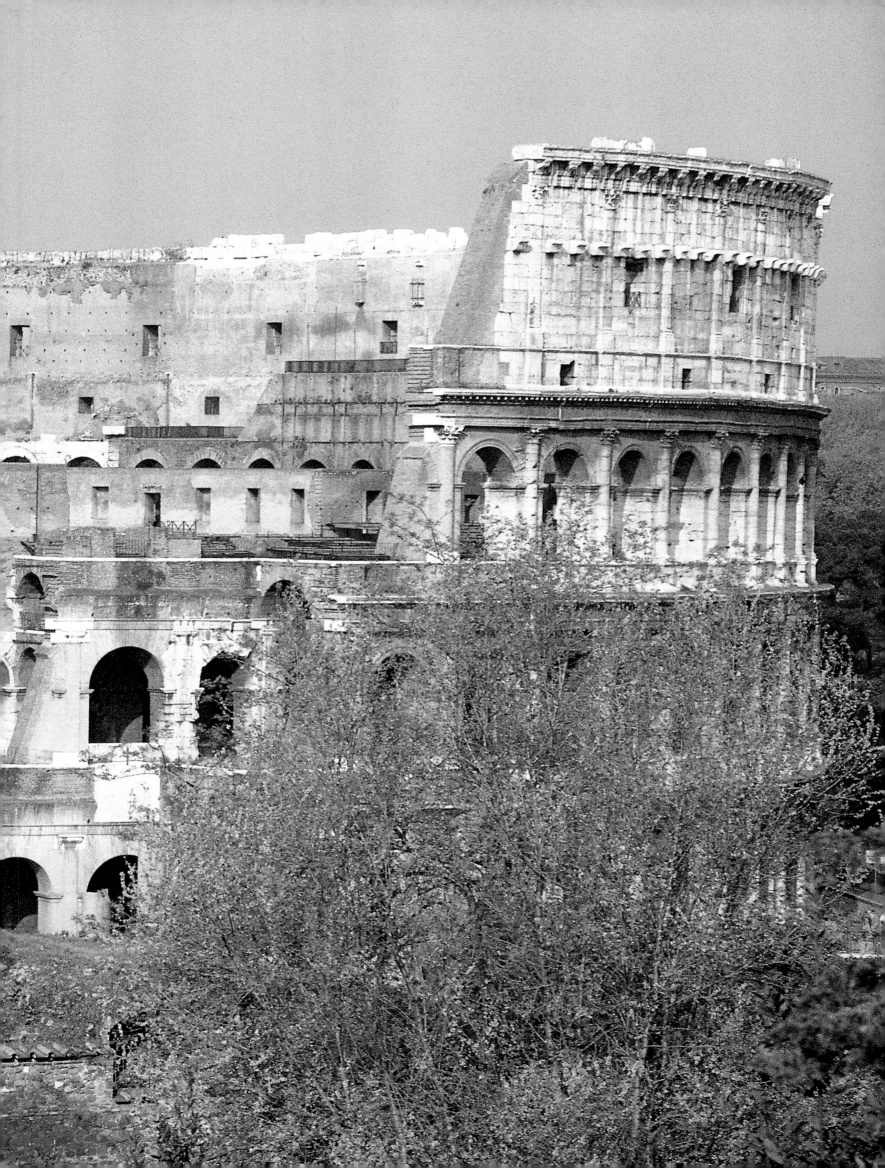

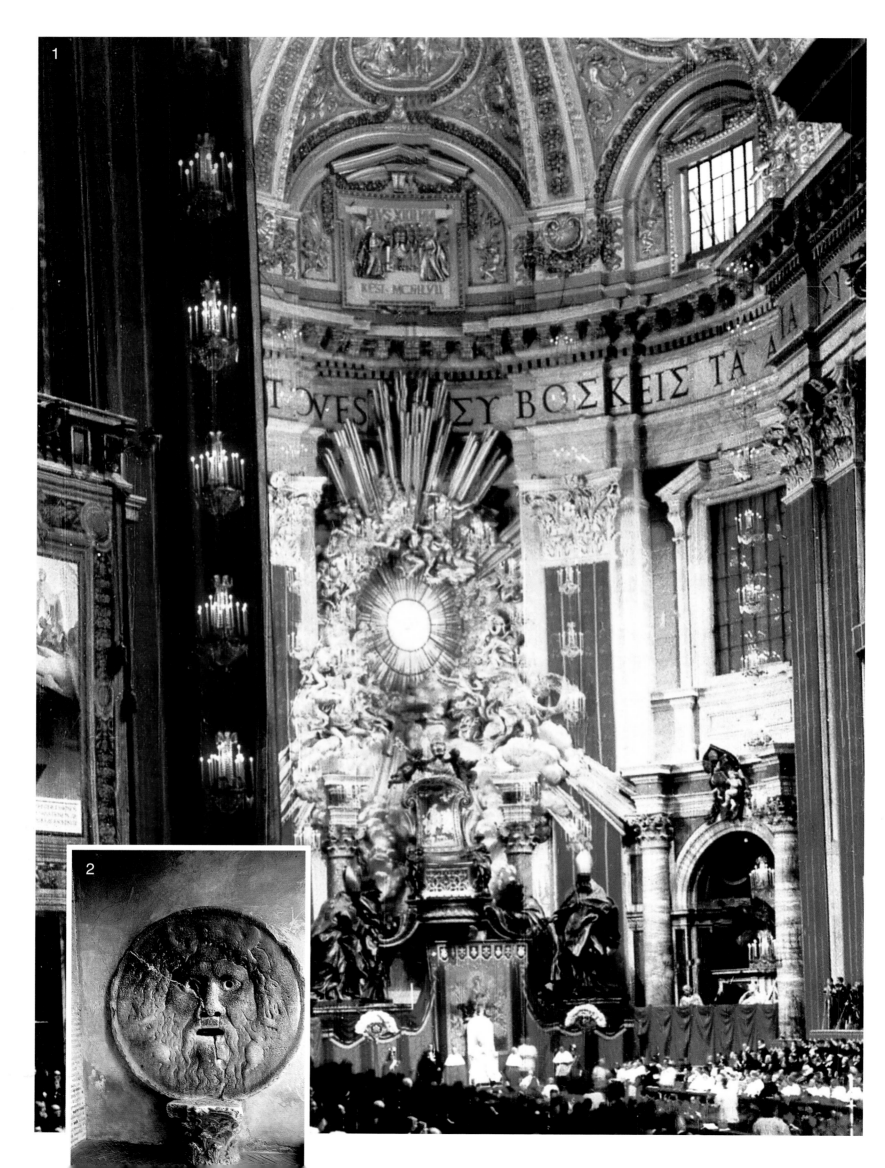

The Rome of legend

According to ancient legend, the union between the god Mars (in Greek, Ares, 'lord of war') and the vestal virgin Rhea Silvia produces twin sons: Romulus and Remus. Their birthplace is Alba Longa, a Latin town in the Alban Hills founded by Ascanius, son of Aeneas, 400 years before the birth of the twins. The life of Romulus is immediately in danger from the hatred borne against him by his uncle Amulius. To save him from certain death, Rhea Silvia resorts to extraordinary measures: she places Romulus in a trough and consigns him to the waters of the River Tiber along with his twin, Remus. The two newborn infants are saved by a she-wolf, who suckles them with the tenderness of a mother. In due course they are taken in and raised by a herdsman named Faustulus. When they become adults, the twins reconquer Alba Longa and jointly found the city of Rome in 753 BC, setting a 'sacred' boundary between them on the Palatine hill. Remus' scorn for this frontier – which he violates in a gesture of defiance – enrages his brother Romulus, who kills him and so becomes the first king of Rome.

Ancient Rome

Historically, Rome arises in a rather broad valley crossed by the Tiber, situated between Etruria, Latium and Campania. The city is formed, around the end of the eighth century BC, by a merging of the inhabitants of various villages in the hills surrounding the site. Legend tells of the seven hills of Rome – the Palatine, the Capitoline, the Quirinal, the Viminal, the Esquiline, the Caelian and the Aventine. Between 753 and 509 BC, when Rome already controls the bordering areas of Latium, city walls are erected. In the fourth century BC these are replaced by what is now known as the Servian Wall, parts of which still survive. This new defensive perimeter is 11 kilometres long, enclosing an

area of 400 hectares. During this period many major edifices are built, the ruins of which can still be seen today: the Forum, the Circo Massimo, the Temple of Jupiter on the Capitoline, etc.

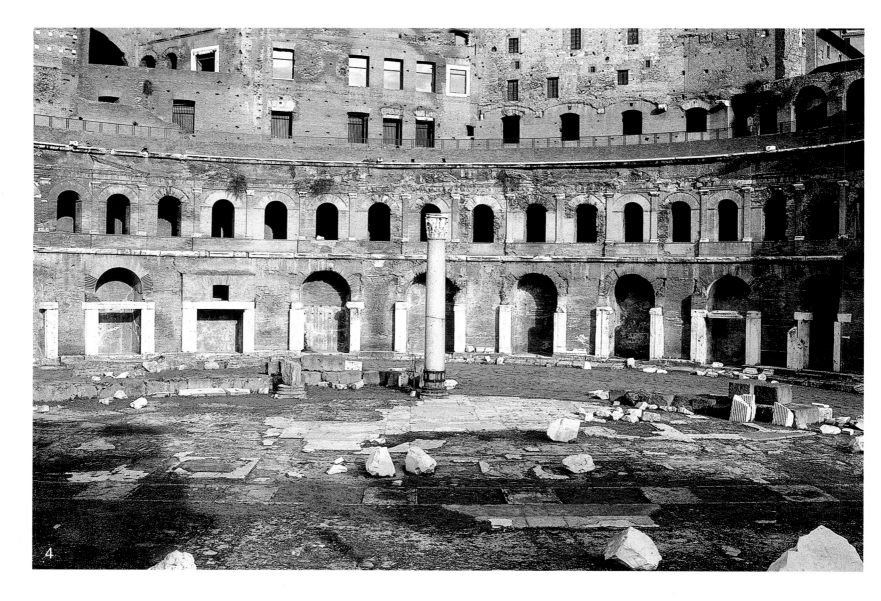

Between 264 and 118 BC, Rome expands by conquering the whole of the Mediterranean basin. The Punic Wars (246–146 BC) mark the start of the great Latin territorial expansion. The Roman militias conquer Sicily in 241 BC, followed by Sardinia in 238 BC and Spain in 201 BC. In 146 BC, it is the turn of the part of Africa dominated by the Carthaginians. In the same year, Rome conquers Macedonia and Greece. Finally, in 133 BC it seizes the kingdom of Pergame.

During the course of the next century, Rome's domination extends into Gaul and North Africa and reaches as far as Asia Minor, Syria and Egypt. However, the full extent of Rome's expansion is not attained until the imperial era between 27 BC and AD 476, and more specifically under the reign of Trajan (AD 53–117). Thanks to numerous conquests, spoils of war and the heavy tributes extracted from annexed provinces, Rome enjoys a period of rapid urban development. Emperor Augustus decides to build new forums. This period produces the Flavian Amphitheatre (known since the Middle Ages as the Colosseum) started under Vespasian and completed under Titus. Also built at this time are the baths of Caracalla and Diocletian, the Arch of Titus, the Arch of Septimius Severus, the Arch of Constantine, Trajan's Column,

4. Mercati Traianei (Trajan's market)
5. Largo Argentina (Argentina Square)
6. Temple of Fortune

Next page:
7. Complesso Coppede (Coppede district)
8. The Piccola Farnesina, loggia

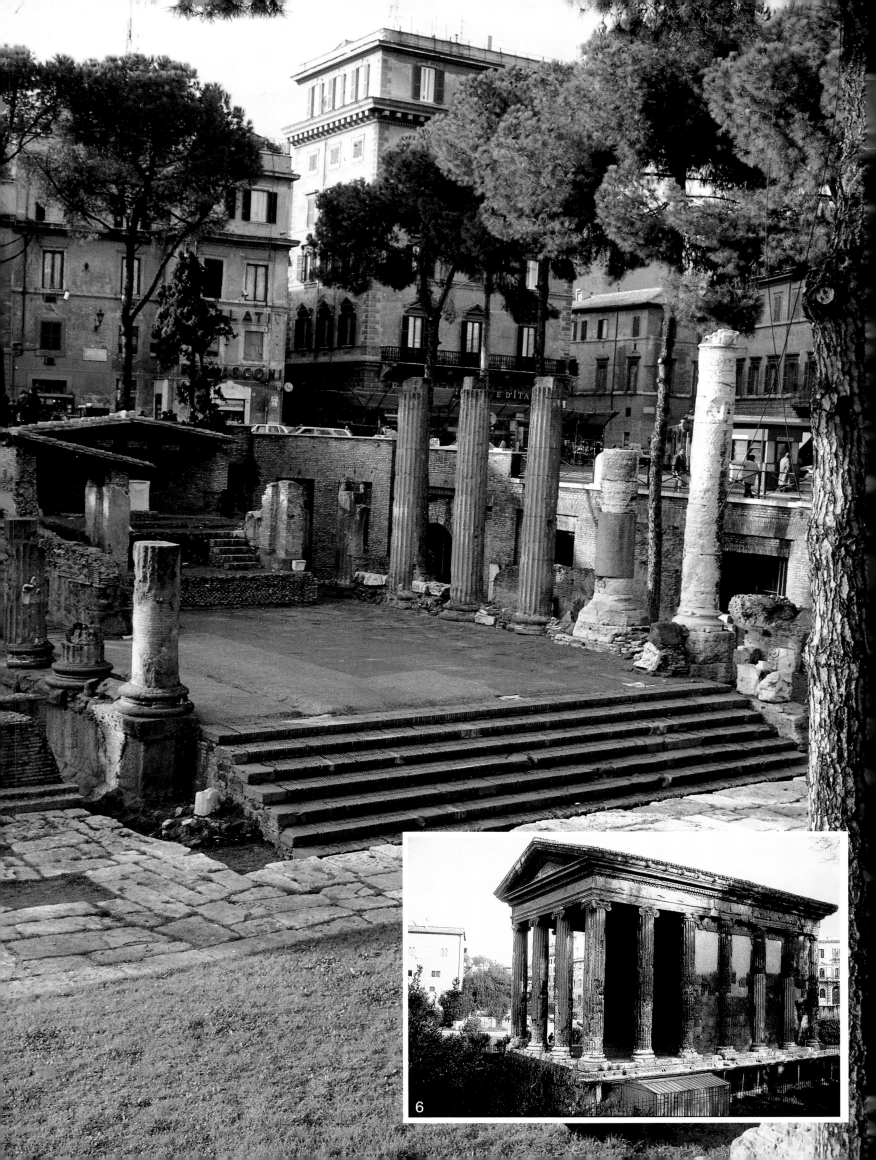

6

Marcus Aurelius' column, the Pantheon – built during the age of Augustus at the behest of General Agrippa – and numerous temples, theatres and warehouses. The city enjoys the apogee of its urban and demographic expansion in the 2nd century AD. After being ravaged in AD 64 by a fire which Nero blames on the Christians, the Eternal City is quickly rebuilt. Between AD 270 and 275, on the orders of Aurelius – who fears devastating invasion by the Barbarians – Rome is surrounded with a defensive wall known today as the Aurelian Wall. Although this protects an area of some 1,400 hectares, it does not encircle the whole of the city.

Medieval Rome

The emperor Constantine, who converts to Christianity after seeing a vision, decides to build three of the four great basilicas: San Giovanni in Laterano, San Paolo Fuori le Mura and Saint Peter's, while the fourth – Santa Maria Maggiore – is built under the rule of Pope Sixtus III (AD 432–440). However, from AD 330 onwards Rome finds economic competition from another great city: Constantinople, known as 'the new Rome'. This marks the beginning of the decline of Rome, hitherto known as the *caput mundi* for its extraordinary military, political and economic power. A momentous event for the whole of the Empire is the 'Sack of Rome'. Between August 24 and 26 in the year AD 410, Alaric – the king of the Visigoths – and his howling barbarians conduct the third siege of the Eternal City, following those of AD 408 and 409. In AD 455, Gaiseric, king of the Vandals, sacks the city once again with unparalleled ferocity. In the wake of these tragic events – amongst which must be counted the seizure of Mediterranean Africa by the Vandals between AD 428 and 430, which partially halts Rome's supply of wheat – the city falls from its old pride. The bloody and devastating Greco–Gothic wars between AD 535 and 553 result in a severe demographic decline for Rome. In addition to the crumbling of its security, the Roman population must also suffer the ravages of bubonic plague in AD 543.

Until AD 730, Rome is governed by the indolence of Byzantine officials, but that year it becomes subject to papal power. Although the protection of the Franks – notably under Pepin III and Charlemagne – allows the papacy to develop and prosper, this power is swallowed up in the collapse of the Carolingian Empire. Consequently, between the tenth and eleventh centuries the city falls under the influence of the great patrician families such as the Teofilatto, Tuscolo and Crescenzi, who engage in power struggles with one another as each strives for control over the papal elections. The accession of Henry III and a reform of the Church put an end to these practices.

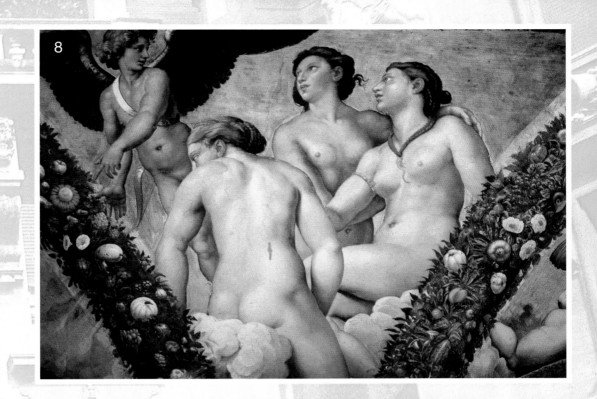

Rome during the Renaissance and Baroque periods

Under Pope Boniface VIII, born of the powerful Caetani family which perpetually struggles with the other noble families of Colonna, Orsini and Savelli for government of the city, Rome enjoys a new era of artistic and cultural glory which culminates in the Jubilee of 1300 decreed by the papal Bull *Antiquorum habet fida relatio* of 22 February 1300. However, the transfer of the papacy to Avignon precipitates a fresh phase of demographic and economic decline. During this period, Rome is administrated by popular *magistratures*.

The murder of Cola di Rienzo in 1354 in an uprising by the nobles prompts the return of Gregory XI to Rome. However, calm is only restored under the pontificate of Martin V Colonna (1417–1431).

During the sixteenth and seventeenth centuries, Rome undergoes a new phase of development. In 1469, the statutes of Rome are reformed. In May 1527, the terrible sack of Rome by the troops of Charles V forces Pope Clement VII to take refuge in the Castel Sant'Angelo until 1528 in order to escape death.

Under the pontificate of Sixtus V (1585–1590), Rome enjoys a strong artistic and cultural flowering. During the early part of the eighteenth century, the papacy becomes the object of wars of succession, while the city suffers harsh poverty between 1716 and 1760.

Rome, capital of Italy

The assassination of General Duphot marks the birth of the Roman Republic, with the help of revolutionary France. The exile of Pope Pius VII to Savone symbolically signals a temporary end to the Church State. In 1810, Rome is declared the second city of the Empire.

However, the real political and social transformation of Rome takes place in September 1870, when it becomes the capital of the Kingdom of Italy.

New buildings are constructed to house the administration, such as the Hotel Patria. Also built at this time is the mausoleum of Victor Emmanuel II, erected at the foot of the Capitoline in 1884. Elegant districts are built for the new aristocracy of politics and the army, such as the Parioli and Ludovisi quarters.

Fascist Rome

During the fascist period, the city enters a new phase of development. Archaeological excavations are undertaken in the Forum, and the Via dell'Impero is laid between the Colosseum and the Piazza Venezia, to be used for fascist meetings. But these works have the effect of pushing the general population out of the centre and relegating it to suburbs such as the Pietralata and Tufello quarters.

9. EUR district
10. Castel Sant'Angelo
11. Temple of Fortune

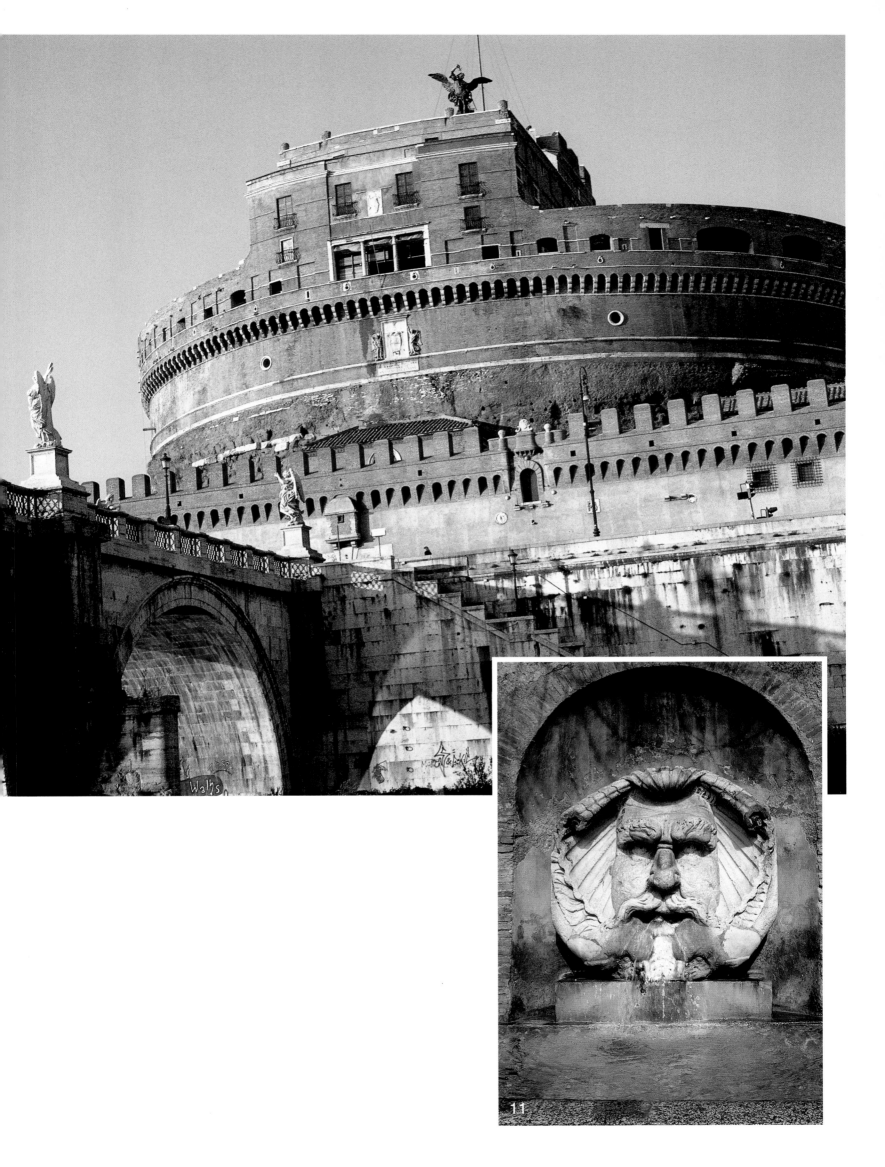

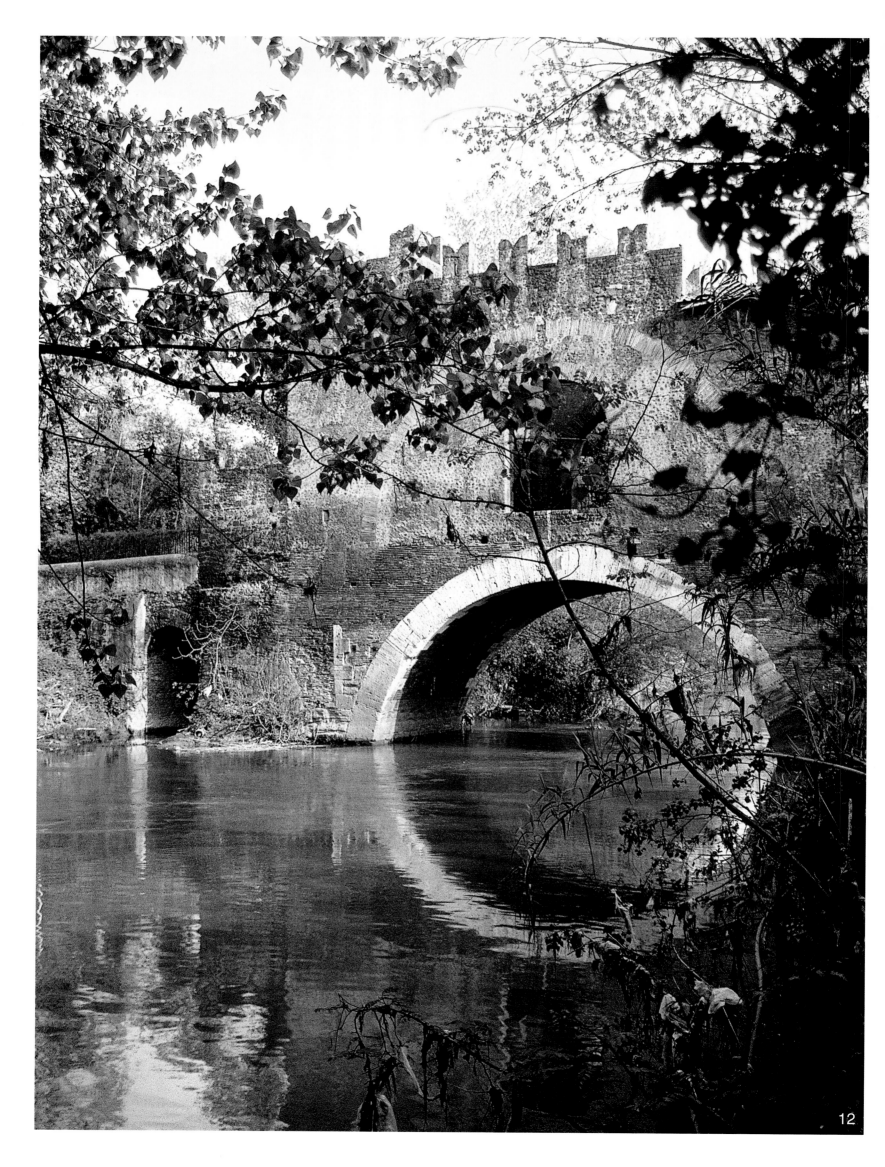

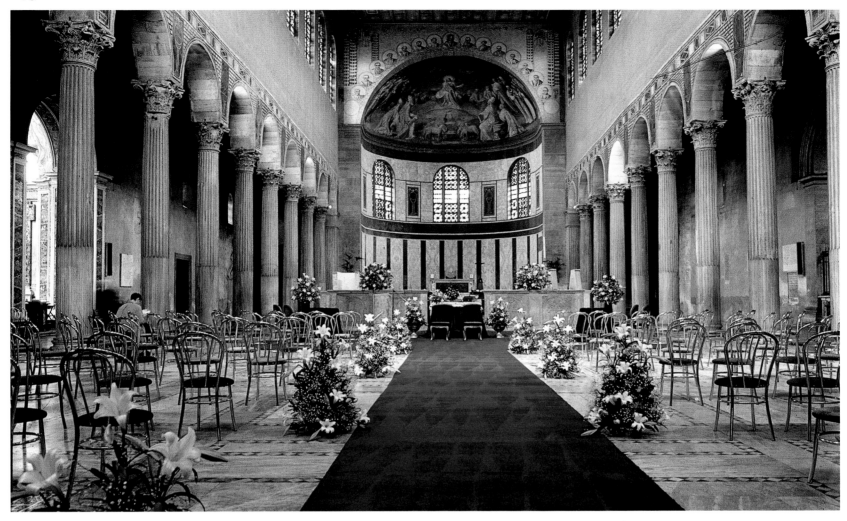

Contemporary Rome

The concreting of the city continues apace at the hands of the 'palazzinari' (unscrupulous entrepreneurs and municipal officials), who build enormous dormitory suburbs. The building programme of the fascist era culminates in the EUR quarter, designed for the Esposizione Universale of 1942. This quarter, like others of the fascist period (Trionfale, Monte Mario, Ostiense) is a prime focus of property speculation. Even today, Rome still suffers the consequences of this in its chaotic traffic, confused town planning and environmental degradation.

We can stroll through Rome by leafing at random through the imperishable pages of Stendhal's *Promenades dans Rome* or Goethe's *Italienische Reise*. We can relive the *Dolce Vita* through the eyes of Federico Fellini by walking in the Via Veneto, or we can cruise around Rome's various quarters by moped, like Nanni Moretti in his film *Caro Diario*. Things have not really changed. We are simultaneously in the past and the present, in this mysterious and enchanting metropolis which still murmurs as ever those eternally romantic words, 'Love and Death'.

The Basilica of San Paolo Fuori le Mura

"Of all the basilicas with colonnaded naves, there is perhaps none more majestic or more Christian." (Stendhal, *Promenades dans Rome*)

Once you have landed at the Leonardo da Vinci Airport in Fiumicino, a fast road takes you directly into Rome. You can reach the centre of the city by taking the Via Ostiense. On this road you will find the famous basilica of San Paolo Fuori le Mura, second in size only to that of San Pietro. The *Liber Pontificalis* tells us that the construction of this basilica was ordered in AD 324 by Constantine at the prompting of Pope St Sylvester (AD 314–335). It is situated precisely on the site of the *cella memoriae* where St Paul was martyred in AD 67. The basilica was completed under Honorius (AD 395–423).

The new basilica was entered through a large portico with four arches and a central fountain. Originally, this portico was provided with five entrances: today there are seven. The first restoration works are carried out in the fifth century under Pope Leo I (AD 440–461). From then on, there is a whole series of restorations and embellishments instigated by successive pontiffs. The last of these, John VIII (AD 872–882), decides to enclose the basilica within a solid wall to protect it against invasions such as that of the Saracens in AD 846. During the eleventh century, two magnificent new features are added to the basilica which can still be seen today: the bell tower erected beside the north nave, close to the facade, and the bronze portal of the main entrance.

Unfortunately, during one of the numerous restorations the basilica suffers a particularly serious fire which destroys a large part of the building.

The reconstruction of the basilica falls to the successor of Pius VII, Leo XII (1823–1827). Two schools of thought contend for the commission: the design offered by the architect Giuseppe Valadier proposes an innovative solution, but the special committee formed for the purpose finally entrusts the project to Pasquale Belli, who advocates a faithful restoration of the original edifice. Under the pontificate of Gregory XVI (1831–1846), the architect Luigi Poletti takes over the supervision of the works from Pasquale Belli, assisted by Pietro Boso, Pietro Camporese and Virginio Vespignani. The pictorial decoration of the naves and the transept, with its portraits of

popes and the cycle of scenes from the life of St Peter, begins in 1857. This is the work of various artists of the Roman School. Works are suspended between 1884 and 1890. On 14 March 1890, the first stone is laid for the four-arch portico designed by Guglielmo Calderini. However, Vespiniani's plans are rejected and the works are not finished until 1928. The reconstruction of the basilica is finally completed in 1931 with the installation of the bronze portal by Antonio Mariani and the building of the baptistery by Arnaldo Foschini.

The Pyramid of Gaius Cestius

"Today I went to the Pyramid of Cestius, and this evening to the Palatine Chapel amidst the great ruins of the Palaces of the Caesars. None of this can be conveyed in words! Truly, the concept of smallness is simply unthinkable there." (Goethe, *Italienische Reise*)

Leaving the basilica of San Paolo Fuori le Mura, after passing along the Via Ostiense through the General Markets, we come to the promenade of the Pyramid of Gaius Cestius. This imposing construction is one of the most characteristic legacies of the Roman era. The monument, which is built of blocks of marble, stands some 36 metres high and 30 metres wide, and is a memorial erected in honour of Gaius Cestius Epulo, a well-to-do Roman who died in 12 BC. It took 330 days to build this pyramid, as inscribed on the face overlooking the square. The inscription also states that the descendants of Gaius Cestius built this monument in compliance with the last wishes of the deceased. Inside the pyramid is a large room decorated with frescoes, but unfortunately there is no public access to this room. The original entrance is still unknown, and the door on the west side dates from modern times. This pyramid marks the boundary of the cemetery known as 'the English Cemetery', where non-Catholics, actors and prostitutes used to be buried. According to Church doctrine of the period, the bodies of such people could not be buried in consecrated ground.

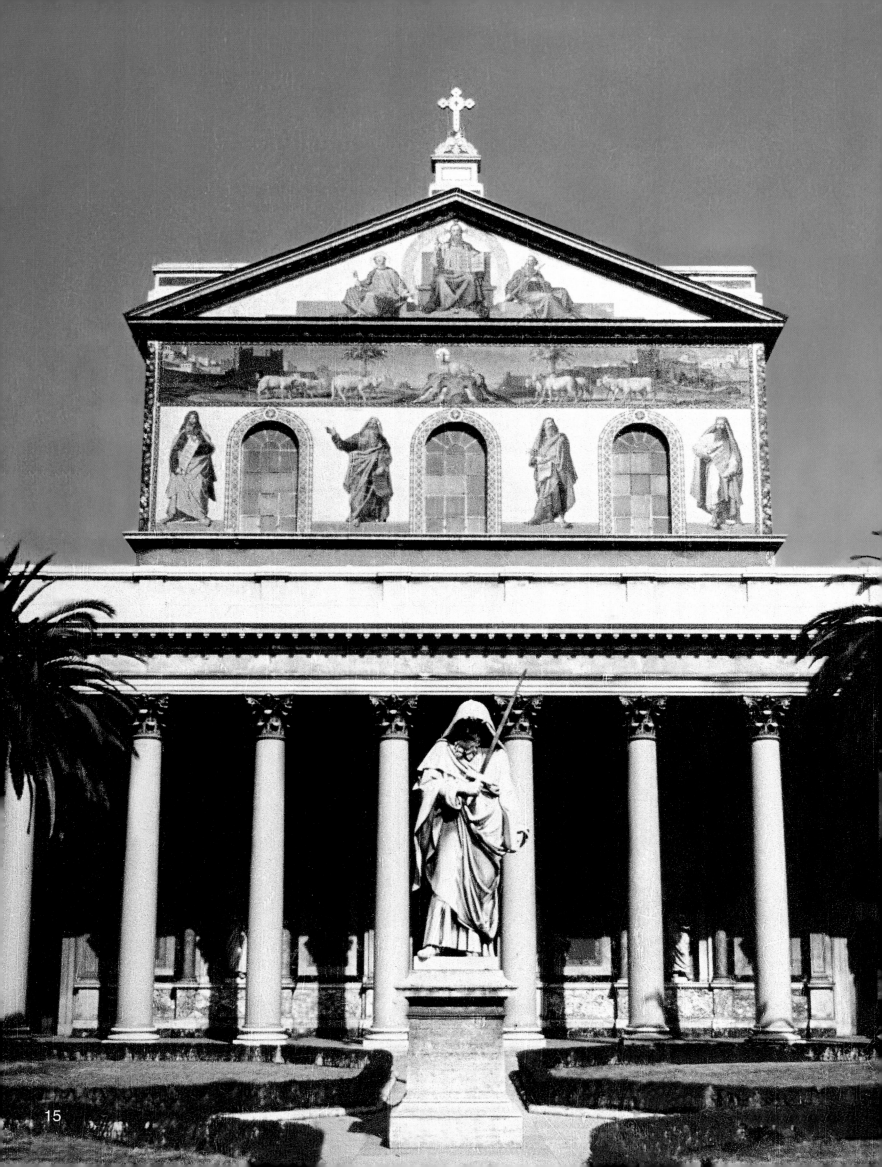

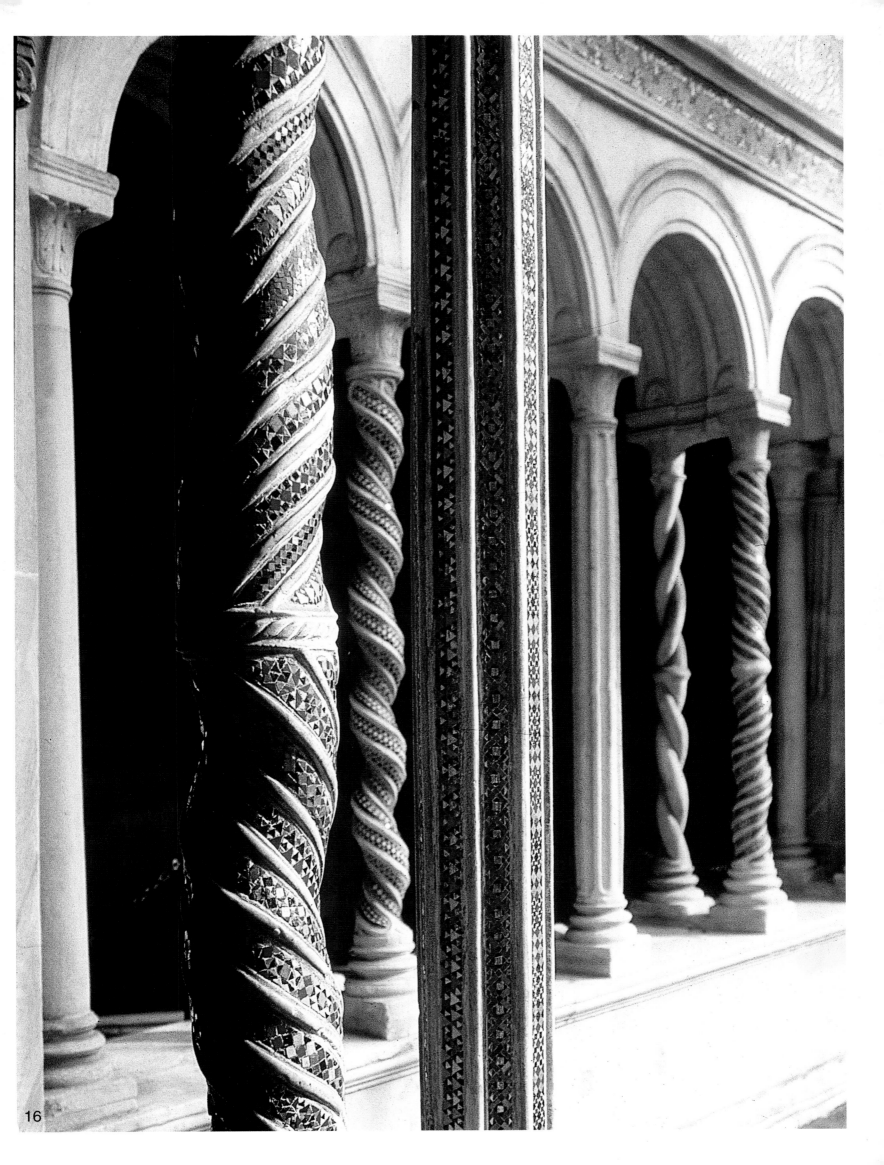

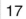

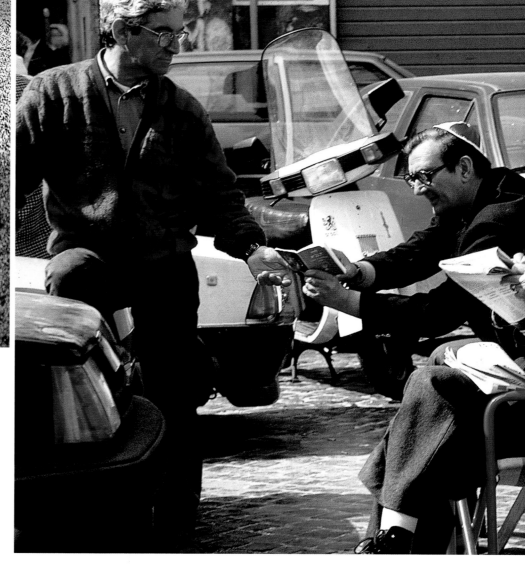

Preceding page:

15. Basilica San Paolo (St. Paul's Basilica)

16. Basilica San Paolo, cloister

17. Chiesa Santa Maria in Cosmedin
(church of St. Mary in Cosmedin)

18. Borgo Pio (Pius district)

19. Ghetto (Jewish Quarter)

20. Jewish Quarter, shop

21. Behind the synagogue

The Theatre of Marcellus

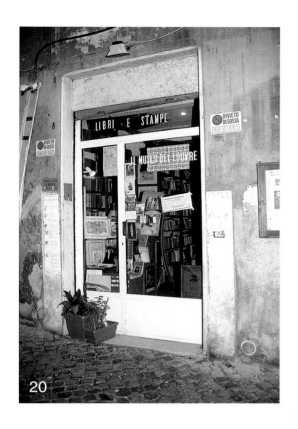

Leaving the Pyramid of Cestius and passing along the Via della Marmorata, we come to the Piazza dell'Emporio. Turning right here, we arrive at the Aventine quay leading to the Via del Teatro Marcello, from which we have an overview of the theatre's arches. The original structure seated some 15,000 spectators. It was built on the orders of Julius Caesar and, as recalled by Stendhal, dedicated by Augustus to his dead nephew and son-in-law, Marcellus. On the facade of this imposing edifice, it is still possible to see three orders of columns: Ionic, Doric and Corinthian. During the Middle Ages, the Theatre is used as a fortress; later, it is bought and used as a residence by powerful patrician families. The first of these is the Pierleoni family, whose name derives from their ancestor Pietro Leone. The second is the Savelli family, well-known and powerful throughout the Middle Ages. The Savellis give the Church two popes: Honorius III et Honorius IV. Next it is the turn of the Massimi, another noble family which traces its lineage back to the Fabii Maximi of ancient Rome. One of their huge villas is erected on the Piazza Cinquecento, now the site of the Palazzo Massimo. Finally, the Orsini family – arch-enemies of the Colonnas – takes possession of the

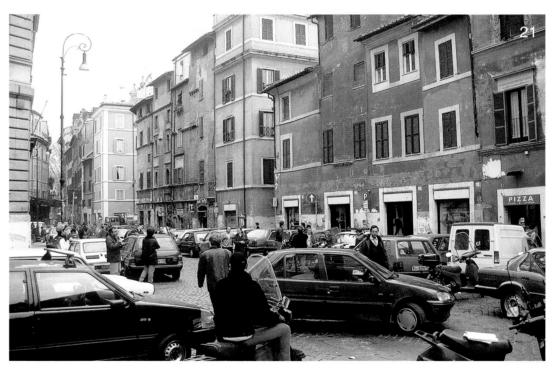

Theatre. In addition to a number of cardinals and captains, this family produces three popes: Celestine III, Nicholas III and Benedict XIII.

In conclusion, the edifice was restored between 1926 and 1932 by Alberto Calza-Bini. Further restoration works were begun in 1992.

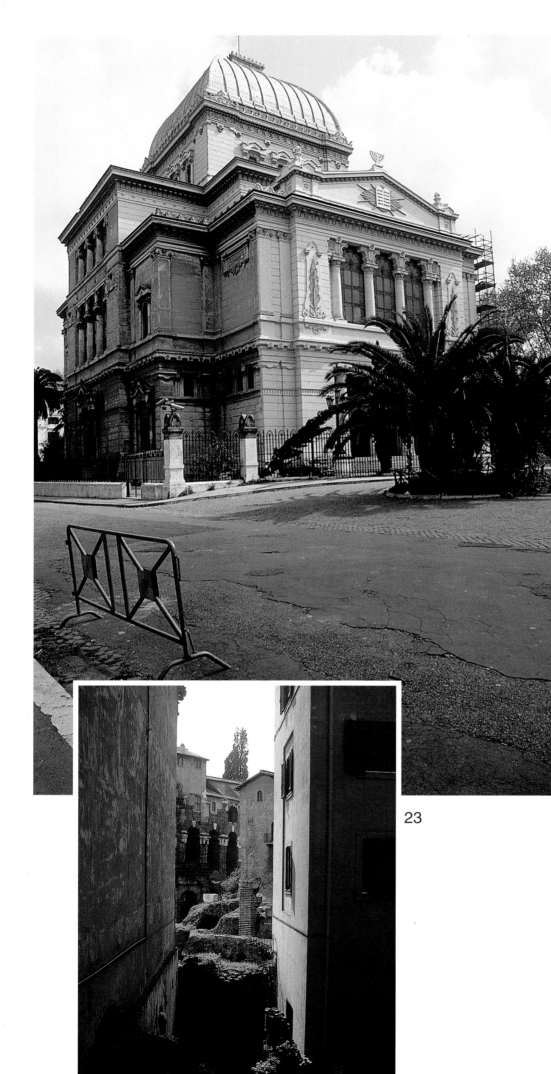

22

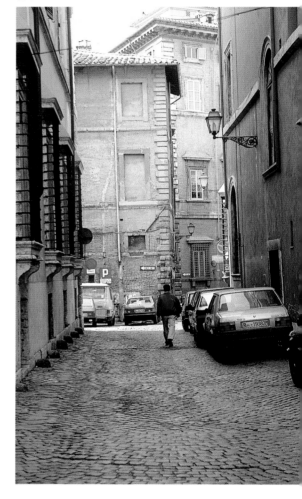

24

23

25

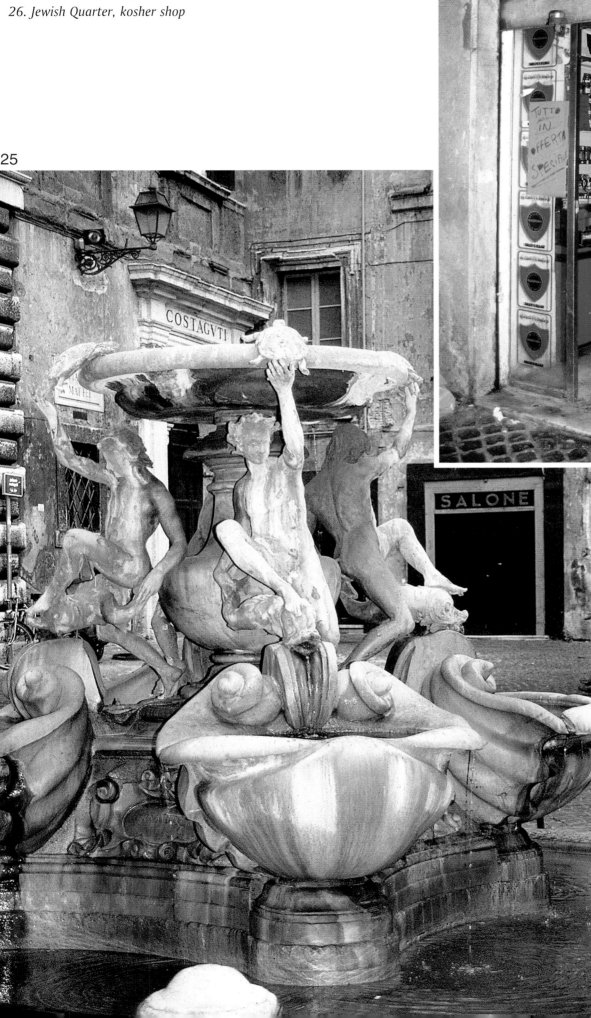

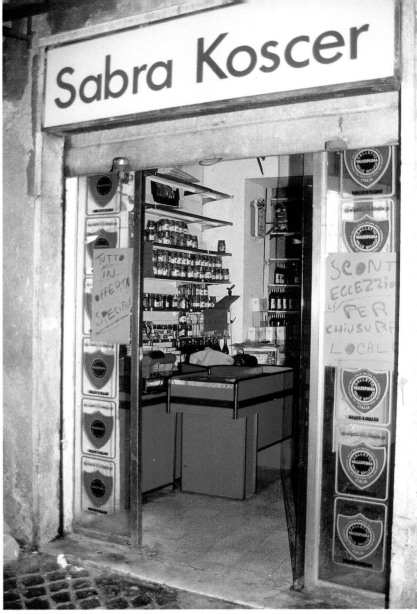

26

Tiber Island and the Trastevere quarter

Turning our backs to the Theatre of Marcellus and moving along the Lungotevere de Cenci, we see Tiber Island on our left. Legend has it that Tarquinius Superbus – the seventh and last king of Rome – having been

overthrown by Brutus and Colatinus in 509 AD, was so hated by the Roman populace that they threw all his wheat into the waters of the Tiber. It is said that the harvest caused the accumulation of sediment which resulted in the formation of the island. In reality, experts have established that the island is actually composed of the same tufaceous materials as the neighbouring hills. The island is also known as l'Isola di Due Ponti (Two Bridges Island), since it is connected to the mainland by two bridges, originally made of wood but subsequently replaced by stone. Initially it is the site of the cult dedicated to the Aesculapius, the god of medicine. Towards the end of the sixteenth century, the first section of the hospital is built, and the entire island becomes a lazaret due to the epidemic of plague which strikes Rome in 1656. Even today, it remains a place of worship and of medical care.

At the end of the Lungotevere de Cenci, at the crossing with the Via Arenula, we turn left and pass over the Ponte Garibaldi to reach the Piazza Sonnino. This brings us directly into the Trastevere quarter, one of the oldest, most picturesque and popular parts of Rome. Its name derives from the Latin *trans Tiberim*, meaning 'across the Tiber'. As well as its unique atmosphere and numerous meeting places, nightclubs, bars and restaurants, the Trastevere quarter is well worth a visit for its extraordinary architecture. The heart of the quarter is considered to be the Piazza Santa Maria in Trastevere. We reach it by leaving the Piazza Sonnino and travelling the full length of the Via della Lungaretta. The square is a meeting place for throngs of young people, who play music, sing and drink around the octagonal fountain built in 1692 by the architect Carlo Fontana da Brusata (1634–1714). At the end of the square is the basilica of Santa Maria in Trastevere. This may have been the first church opened for worship in Rome. According to tradition, it was founded by Pope St Calixtus.

27. Trastevere district

28. Foro Romano (Forum Romanum)

29. Settimiana Square, Trastevere

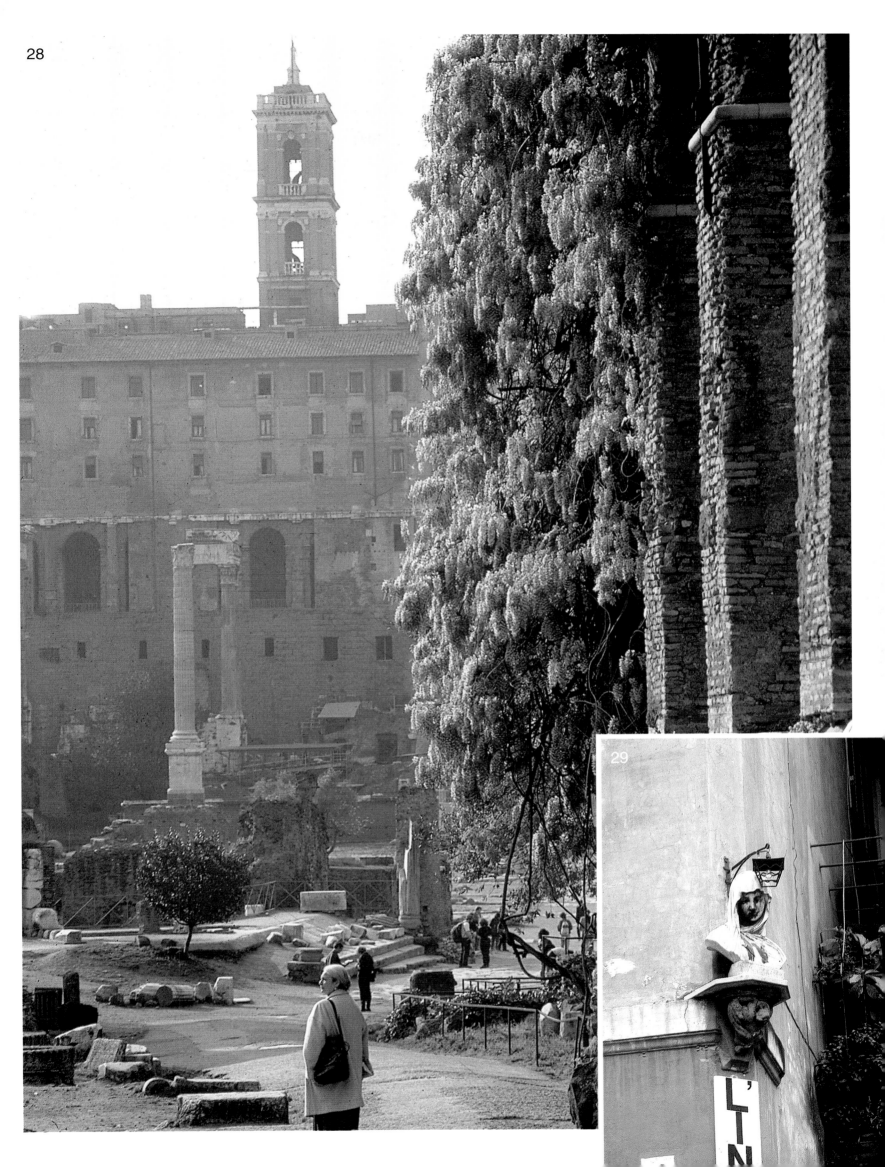

28

29

32

30–32. Porta Portese market

31

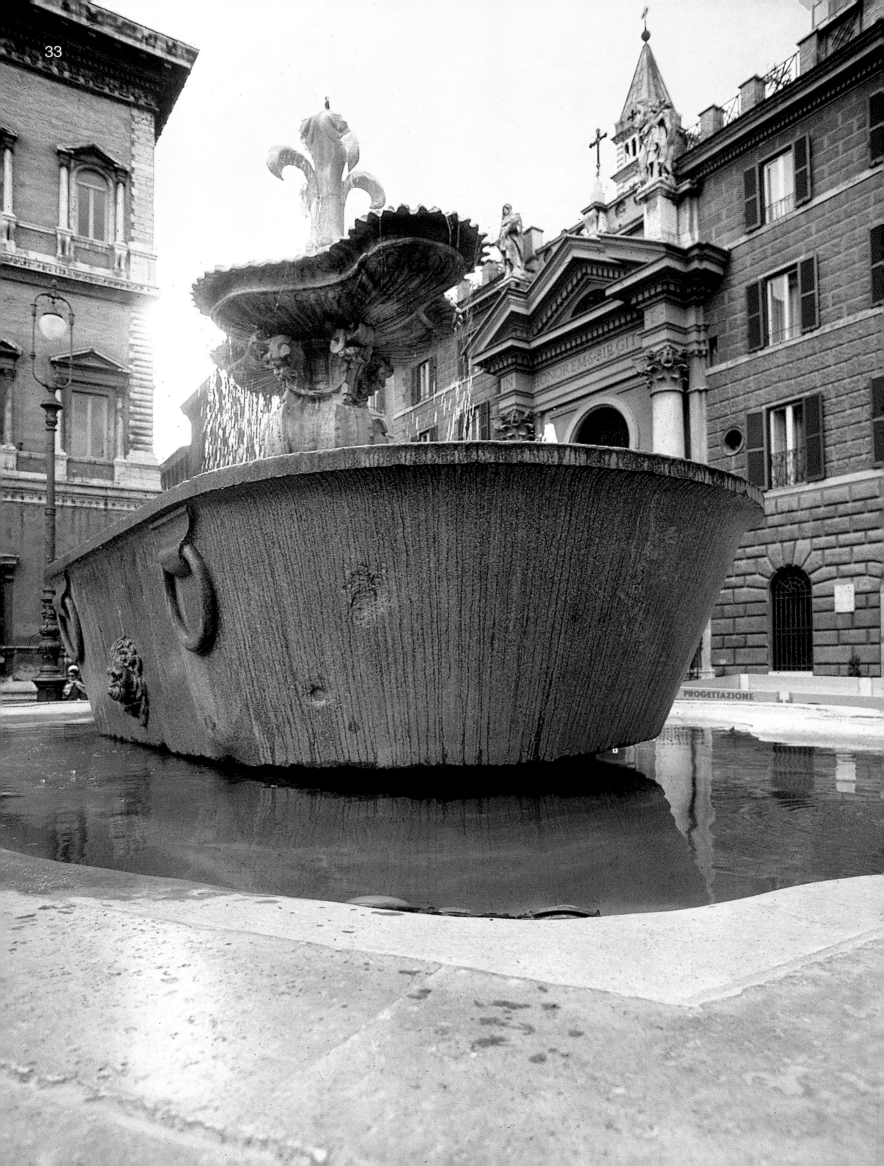

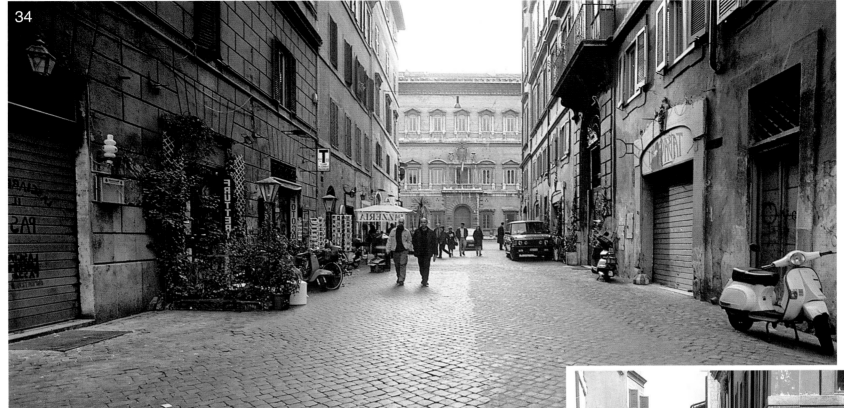

The Palazzo Farnese

Returning to the Piazza Sonnino and then traversing the length of the Lungotevere Sanzio, we come to the Ponte Sisto. On the other side of the bridge, we find ourselves at the start of the Via dei Pettinari. At the far end of this road we take the first right into Via Capo di Ferro, which leads us to the Piazza della Quercia. Adjacent to this square is the huge Piazza Farnese, ornamented with twin fountains attributed to Girolamo Rainaldi. We come to a halt in front of the majestic Palazzo Farnese, an entirely unique building which dates from the Renaissance. Construction begins in 1517 on the orders of Cardinal Alessandro Farnese, who is elected Pope in 1534 under the name of Paul III. The work is entrusted to the remarkable and renowned Florentine artist Antonio da Sangallo the Younger. On his death, the project is handed over to Michelangelo and Vignola, although the structure is completed only in 1589 by Giacomo della Porta. The magnificent facade has an extremely attractive corniche decorated with Farnese lilies. Today, the Palazzo Farnese is the home of the French Ambassador to Italy. Its interior is truly sumptuous, and is reached by passing through a monumental hall created by Antonio da Sangallo the Younger, with colonnades of red granite. It is also well worth visiting the vast gallery (approximately 120 m^2), highly regarded for its frescoes by Annibale Carracci (1597–1604).

33. Palazzo Farnese Square
34. Near Palazzo Farnese
35. Trastevere district

Next page:
36. Fresco by Raffaello and Giulio Romano, the Piccola Farnesina
37. Lo Spinario, bronze, 1 AD, anonymous, Conservatory Museum, Campidoglio Hill

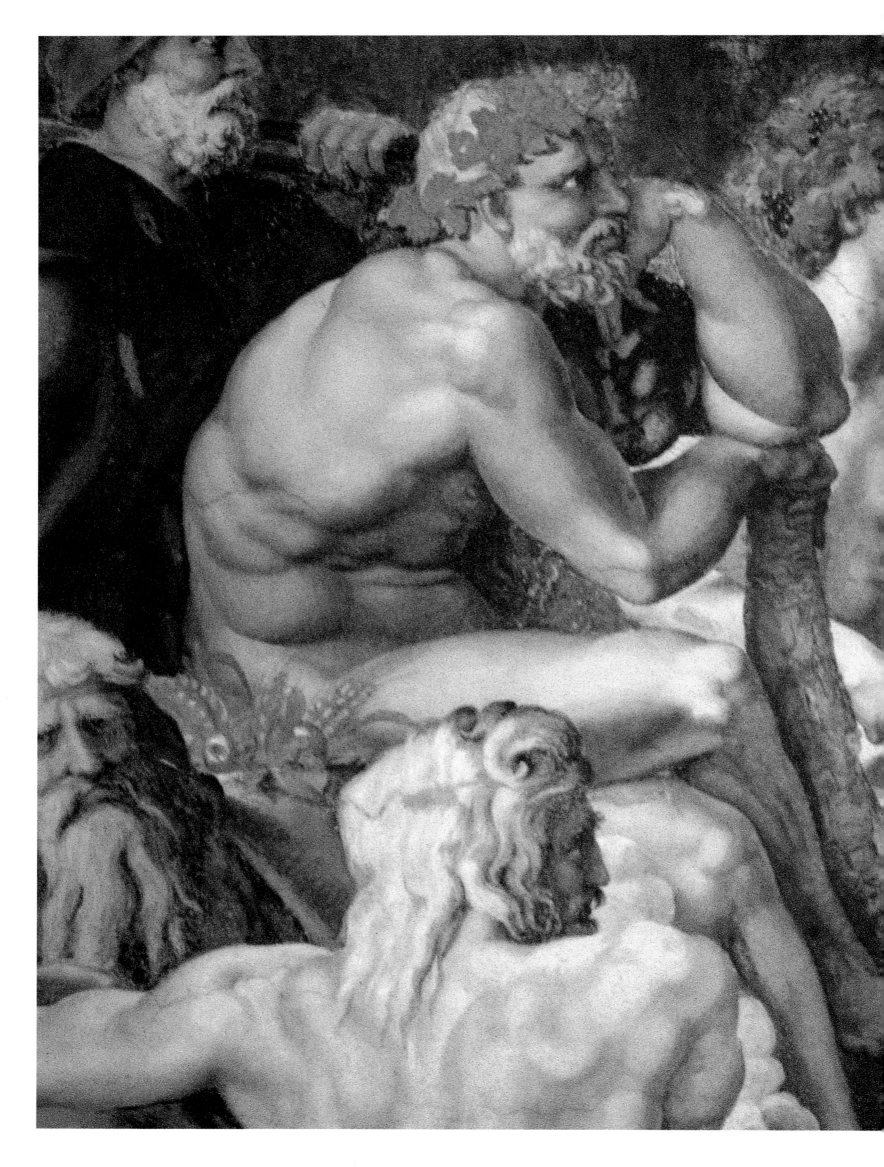

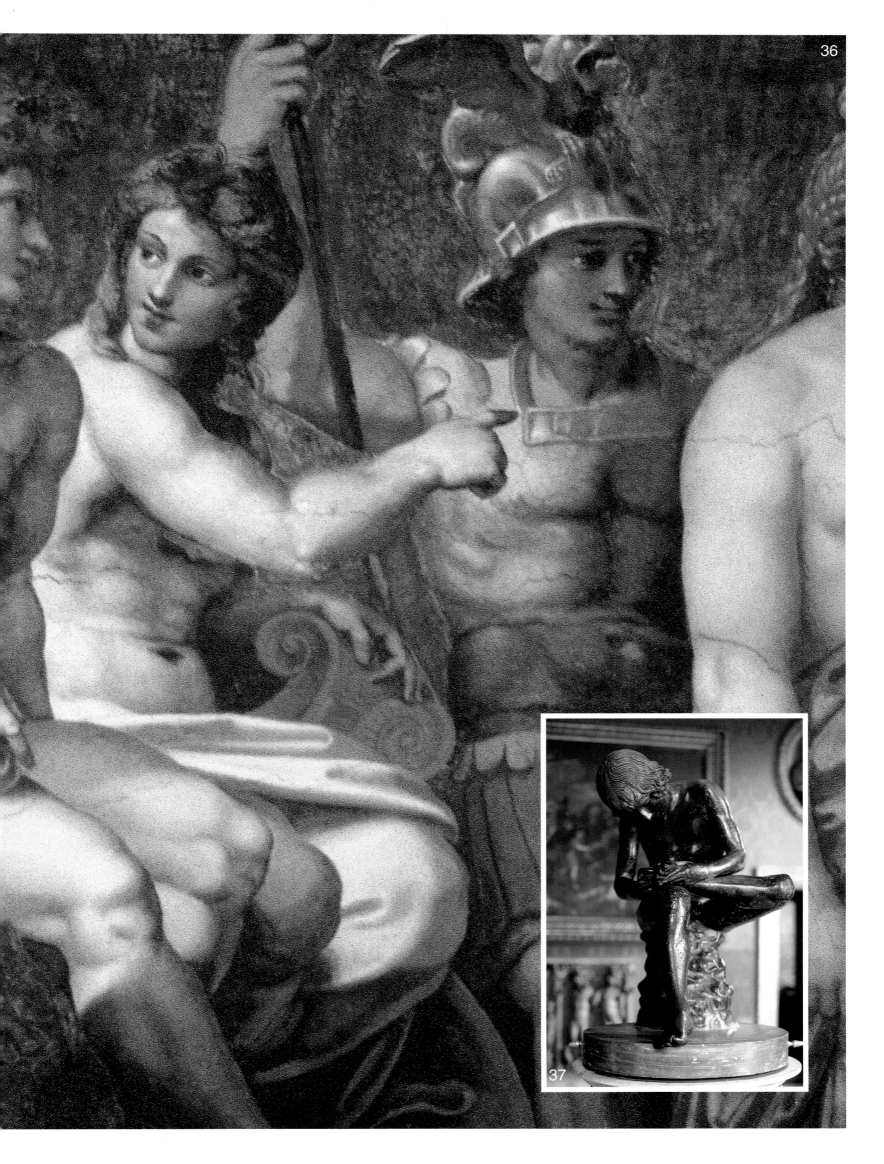

37

Campo de Fiori

From the Piazza Farnese, we take the Via dei Baullari to arrive at another celebrated and characteristic square: the Piazza Campo de Fiori. This is the site of the famous monument dedicated to Giordano Bruno. Accused of heresy, Bruno flees the Neapolitan monastery of St Dominic in which he is a monk, and is burned alive in this square on 17 February 1600. In memory of this tragic event, the bronze monument is erected by Ettore Ferrari in 1887. In his hand the philosopher holds the book of his philosophical theories. Every day, between eight in the morning and three in the afternoon, there is a flower market in the square, full of varied and dazzling colours.

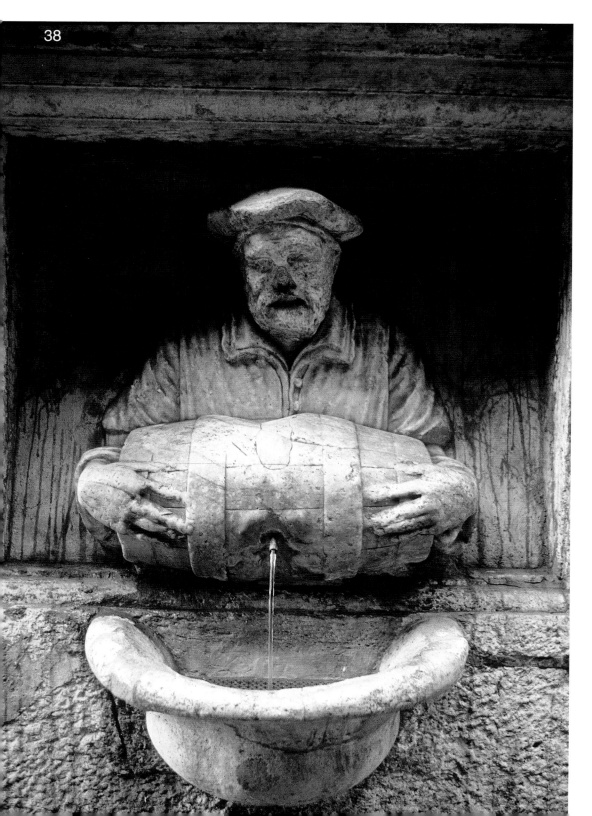

38. The porter, Via Lata
39, 40. The Pantheon

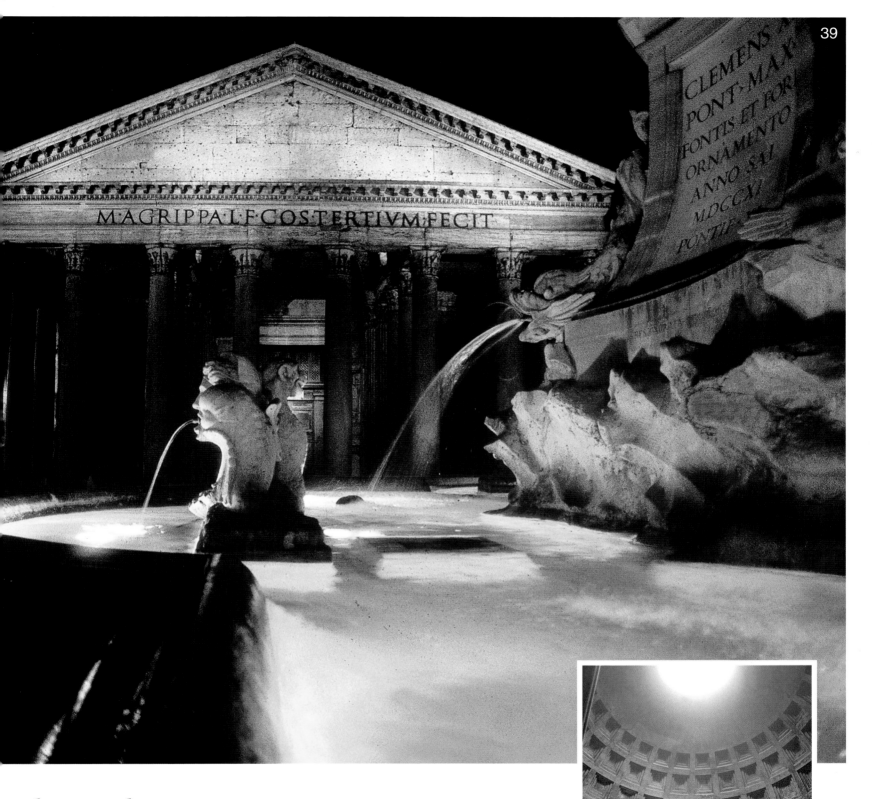

The Pantheon

Taking the Via dei Baullari, we arrive at the Corso Vittorio Emanuele II. Here we turn left along the Via Monterone to reach the Piazza Sant'Eustachio. This square is famous throughout Rome for the Bar Sant'Eustachio, which serves the best coffee in the capital. Now we follow the Via Sant'Eustachio to reach the beautiful Piazza della Rotonda, in the centre of which is the fountain ornamented with dolphins and masks by Giacomo della Porta and the sculptor Leonardo Sormani. Here we find the magnificent Pantheon with its characteristic *tympanum* porch. The word *Pantheon* – originally in Greek and then in Roman religion – signifies a temple dedicated to all gods, both known and unknown. The Pantheon is especially sacred to those gods who do not have their own individual temples. The Pantheon of Rome is perhaps

the most famous in the world. The cylindrical external structure and the interior are very well preserved. It was built on the Campus Martius in 27 BC on the orders of the Roman general and politician Marcus Vipsanius Agrippa, who fought faithfully for his father-in-law Augustus.

The Pantheon is given a new structure after it is devastated by fire in AD 80. The restoration is begun by Emperor Domitian and continues under Diocletian.

The original temple does not take the form of the rotunda we see today: like all the classical temples, it is built to a rectangular plan. Only when the emperor Hadrian decides to have it rebuilt between AD 118 and AD 125 does it acquire its unusual cylindrical shape.

After being abandoned to the ravages of wind and weather for some two hundred years, in AD 608 the temple is donated by the Byzantine emperor Phocas to Boniface IV, who consecrates it to the Virgin Mary and all the martyrs. Subsequently the Pantheon undergoes numerous modifications and restorations until, in 1870, it is turned into a crypt for the kings of Italy.

The interior is divided into seven great niches, alternately rectangular and semi-circular, which house chapels containing important works of art from the Romano-Byzantine period.

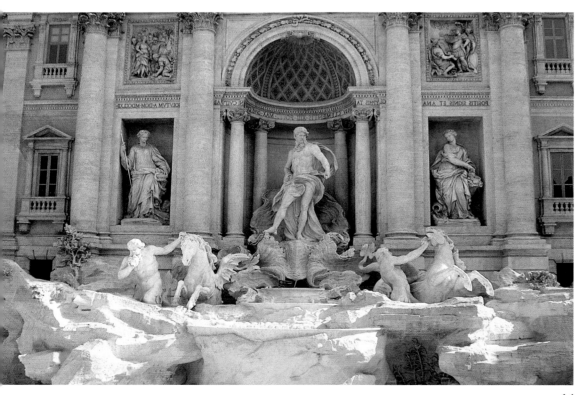

41. *Fontana di Trevi (Trevi Fountain)*
42. *Piazza di Trevi (Trevi Square)*
43. *Fontana del Tritone (Triton Fountain)*

The Trevi Fountain

From the Piazza de la Rotonda we take the Via dei Pastini to the Piazza di Pietra, where we pick up the Via delle Muratte. After crossing the Via del Corso, this takes us to the Piazza de Trevi. This little square is the home of the enormous and celebrated Trevi Fountain. The construction of this magnificent piece of architecture, which abuts against the Palazzo Poli, is ordered by Clement XII (1730–1740). Work commences in 1732 under the supervision of Niccolo Salvi, and is continued by Giuseppe Pannini in 1751. Inauguration does not take place until 1792 under the pontificate of Clement XIII. This splendid monument has recently been restored (1989–1991).

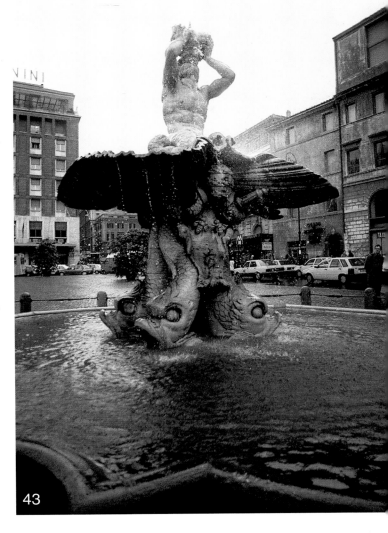

43

The statue in the central niche of the fountain is the work of the sculptor Pietro Bracci (1759–1762), and depicts Oceanus as a charioteer. His chariot takes the form of a seashell drawn by white horses, one of which is rearing up on its hind legs. The horses are in turn led by Tritons. To either side of Oceanus, in two small niches, are allegorical figures representing Health and Abundance. Health is the remarkable work of the sculptor Filippo della Valle. Above this is a statue of the Virgin Mary (by Andrea Bergonde) pointing the soldiers towards the source. Above Abundance, which is also the work of Filippo della Valle, is a statue of the general Agrippa approving the plans for the Roman Aqueduct.

The great basin into which the waters of the fountain flow evidently represents the sea. An ancient Roman tradition, which persists today, says that anyone who throws a coin over his or her shoulder into the fountain will one day return to Rome.

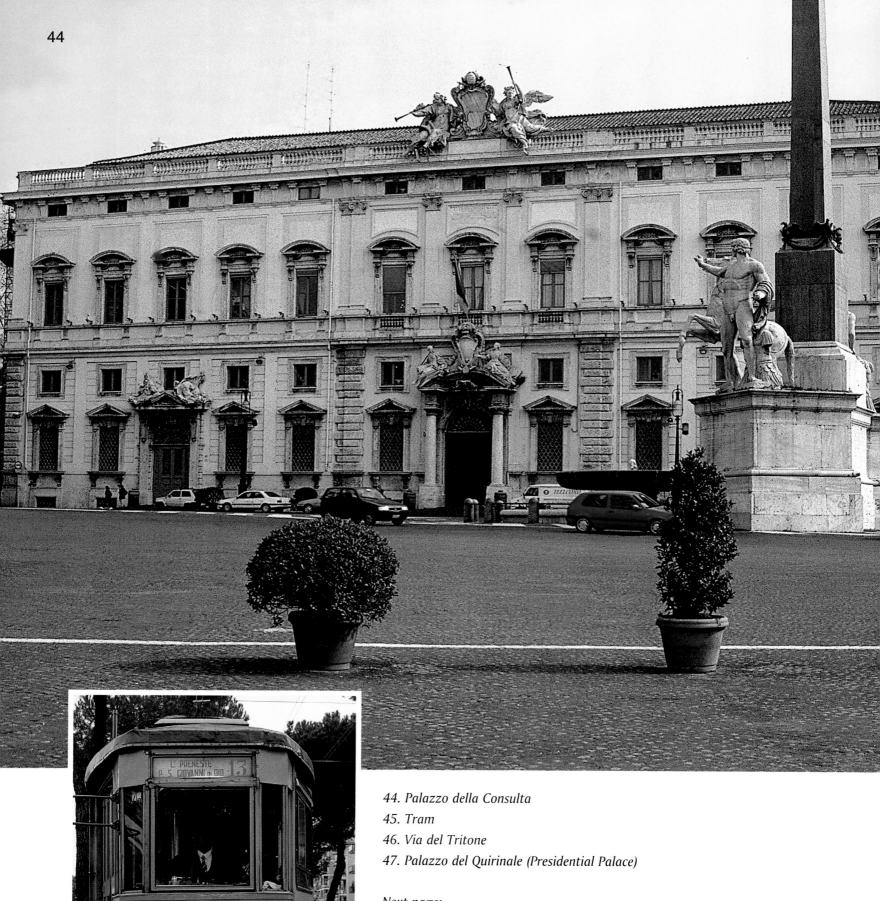

44. Palazzo della Consulta
45. Tram
46. Via del Tritone
47. Palazzo del Quirinale (Presidential Palace)

Next page:
48. Chiesa Sant'Andrea (St Andrew's Church)

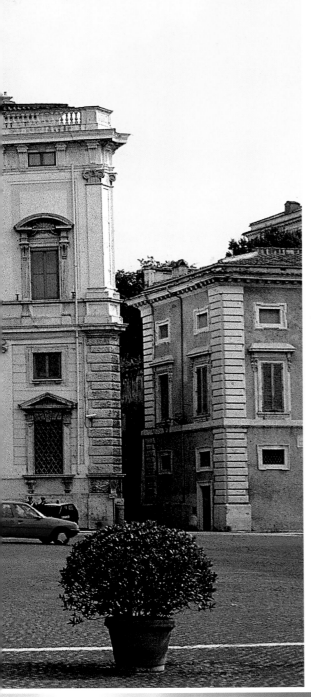

46

47

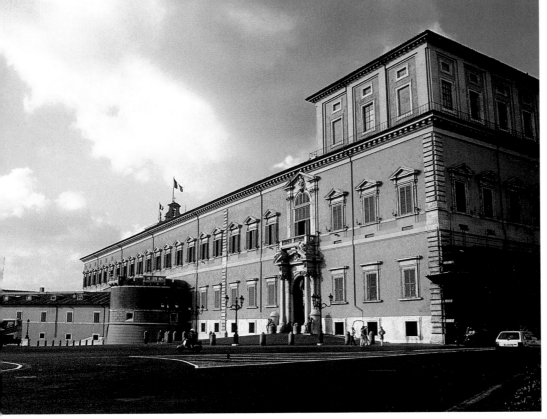

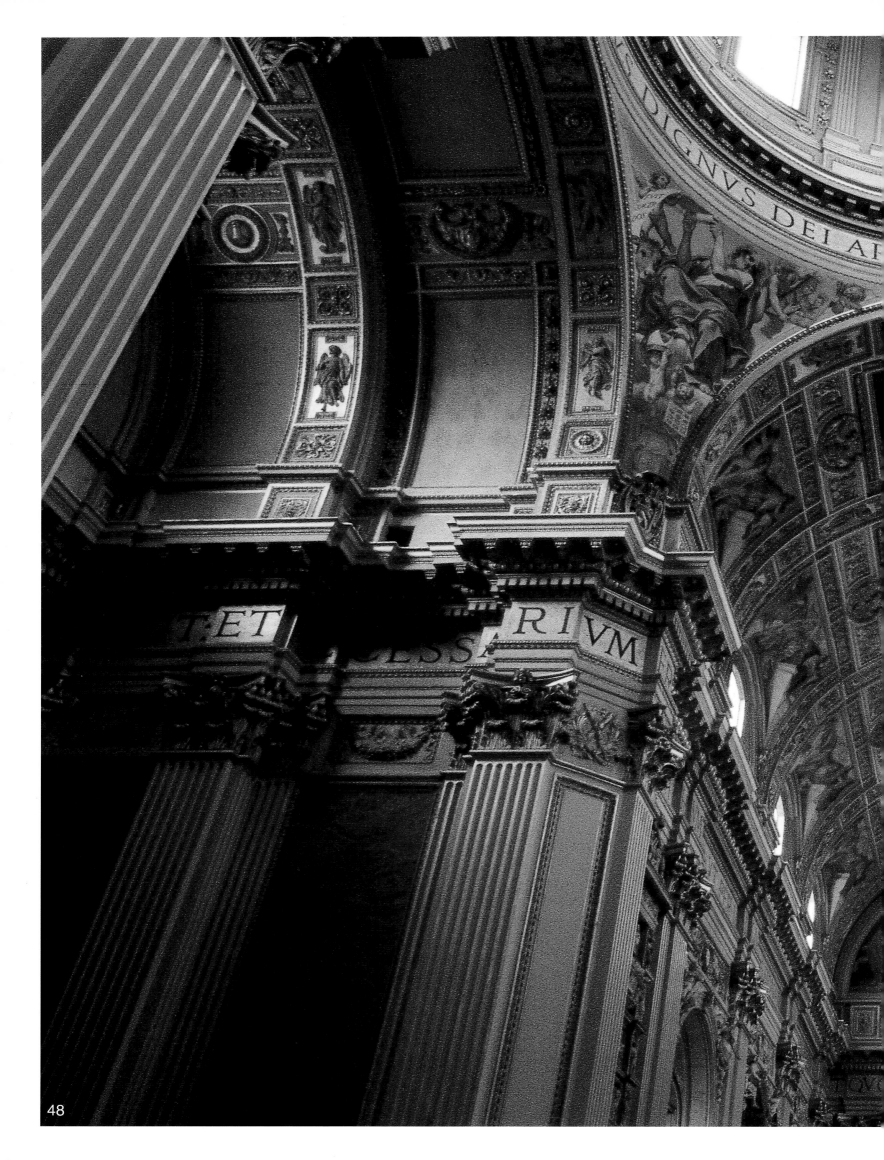

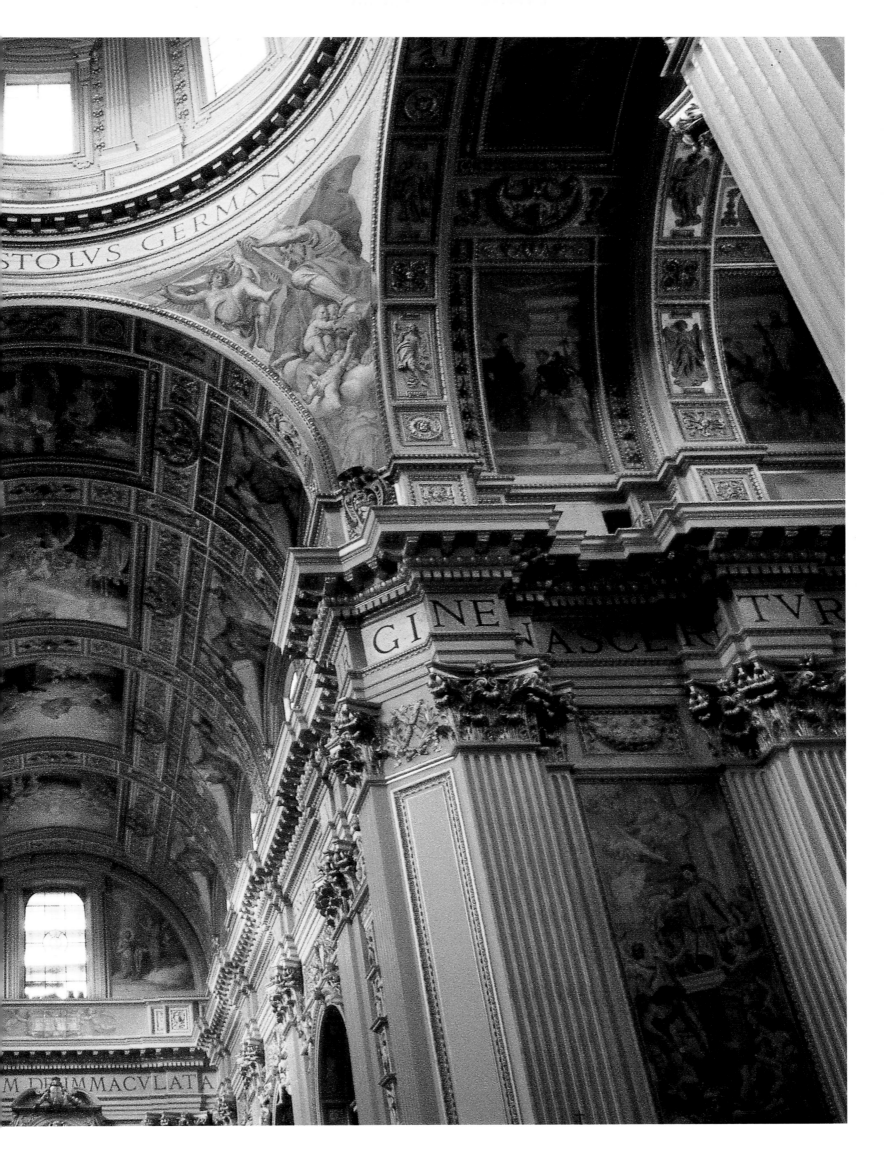

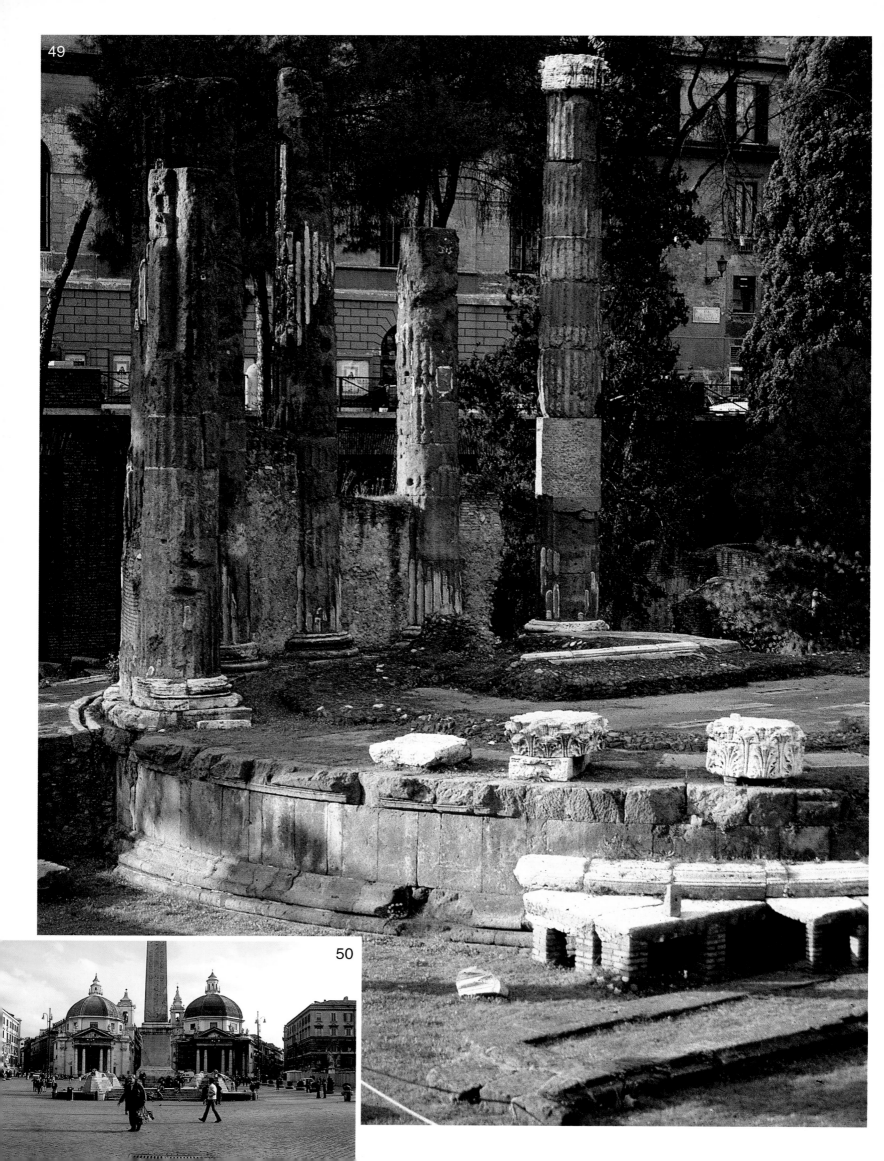

49

50

The Piazza del Popolo and the Piazza di Spagna

Taking the Via delle Muratte and then turning right on to the Via del Corso, we soon come to the Via dei Condotti on our right. This street is world-famous for being the home of the shops of the top Italian designers. After passing along the Via dei Condotti, we arrive at the Piazza di Spagna, one of the most beautiful squares in the world.

Until the seventeenth century this square was called *Platea Trinitatis*, after the church by which it is dominated. It subsequently acquired the name Piazza di Spagna on account of the fact that the Spanish Ambassador's residence was situated here. In the centre, in front of the Scalinata della Trinità dei Monti (popularly known as the Spanish Steps), is the Barcaccia fountain, erected in memory of the flooding of the Tiber in 1598. This was designed in 1629 by Pietro Bernini, with the help of his son Gian Lorenzo. Behind the fountain rises the monumental Scalinata della Trinità dei Monti, famous for its ornamentation and architecture so typical of the Baroque period. The staircase was built between 1723 and 1726 by Francesco de Sanctis on the orders of Pope Innocent XIII. From the Piazza di Spagna, we take the Via della Croce to rejoin the Via del Corso. Turning right and travelling the length of the Via del Corso, we arrive at the Piazza del Popolo. This square can also be reached by the Piazzale Flaminio, which is separated

from the Piazza del Popolo by the Porta del Popolo. This has been the main entrance to the northern part of the city for over 1,500 years. It underwent alterations between 1877 and 1879, during which the two 15th-century towers were demolished. To the left of the Porta del Popolo stands the church of Santa Maria del Popolo, originally a small chapel built in 1099 on the orders of Pope Pascal II to mark the liberation of the Holy Sepulchre by the Crusaders. In the centre of the square is the imposing Obelisk of Flaminius, the tallest and oldest in the city after that of San Giovanni in Laterano. The obelisk was built in Heliopolis by Rameses II around 1200 BC, and transported to Rome by Emperor Augustus as an ornament for the Circo Massimo. Only in 1589, on the wishes of Pope Sixtus V, was it placed on its present site by the architect Domenico Fontana. Embellishments were added in 1823 by Giuseppe Valadier (1762–1839). Finally, the twin churches of Santa Maria dei Miracoli and Santa Maria in Montesanto were built between 1662 and 1679 by Carlo Fontana and Carlo Rainaldi, under the supervision of Bernini, to enclose the square. This spot marks the beginning of the famous *tridente* – the threefold crossroads of the Via del Babuino, the Via del Corso and the Via di Ripetta.

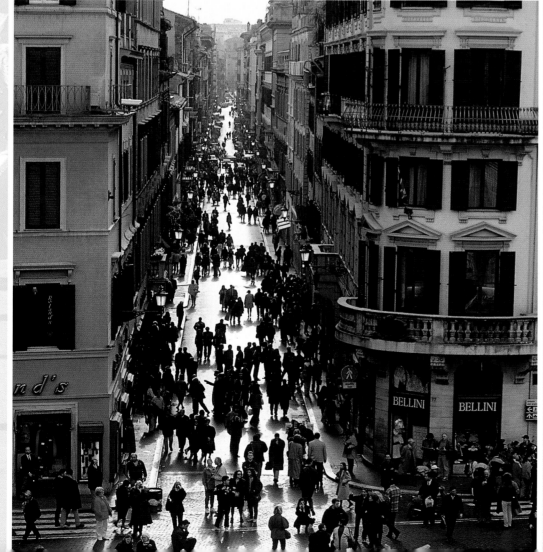

The Vatican Museums

Passing through the portal constructed in 1932 by Giuseppe Momo, depicting Raphael and Michelangelo, we arrive at the Vatican Museums, which are exceptionally rich and extensive. Once through the Momo Gate,

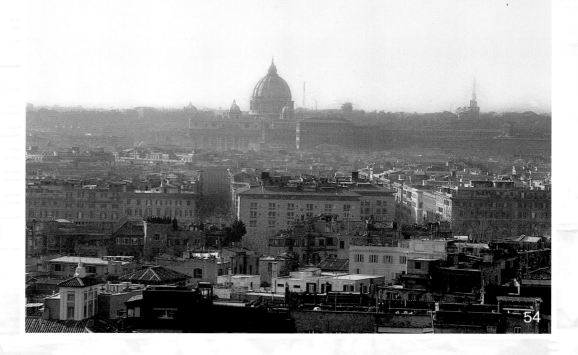

we enter the vestibule containing busts and Roman mosaics. Next is the Cortile delle Corazze, featuring the Column of Antoninus the Elder, erected by his children in AD 161. This brings us to the Sala dei Quattro Cancelli containing, on the upper floor, the Sala della Biga. Taking the Simonetti staircase, we can visit the Gregoriano Egizio Museum, founded in 1839 and comprising nine rooms. Passing through the Cortile della Pigna, which features an enormous bronze pine-cone formerly housed in St Peter's Basilica, we arrive at the Chiaramonti Museum founded by Pope Pius VII. Yet to come are the Galleria Lapidaria, the Braccio Nuovo and the Museo Sacro containing the Galleria degli Arazzi, the Galleria delle Carte Geografiche, the Museo Profano, the Salone Sistino, the Appartamento Borgia, the Stanze di Raffaello, the Cortile di Pappagallo, the Loggia di Raffaello, the Cortile di San Damaso and the Cortile dei Sentinelle.

The Sistine Chapel is world-famous for its frescoes by Michelangelo. It is 40.5 metres long by 13.20 metres wide, with a ceiling 20.7 metres in height. On the far wall, we can admire the masterpiece *Last Judgement* painted by Michelangelo between 1536 and 1541. Restoration of this work was completed in 1993. It is also recommended to visit the Nozze Aldobrandine, the Vatican picture gallery whose origins date back to Pope Pie VI, who wanted to gather together all the paintings kept in the various pontifical palaces. Finally, we should also mention the following museums: the Gregoriano, the Pio Cristiano, the Missionario Etnologico and the Storico Vaticano.

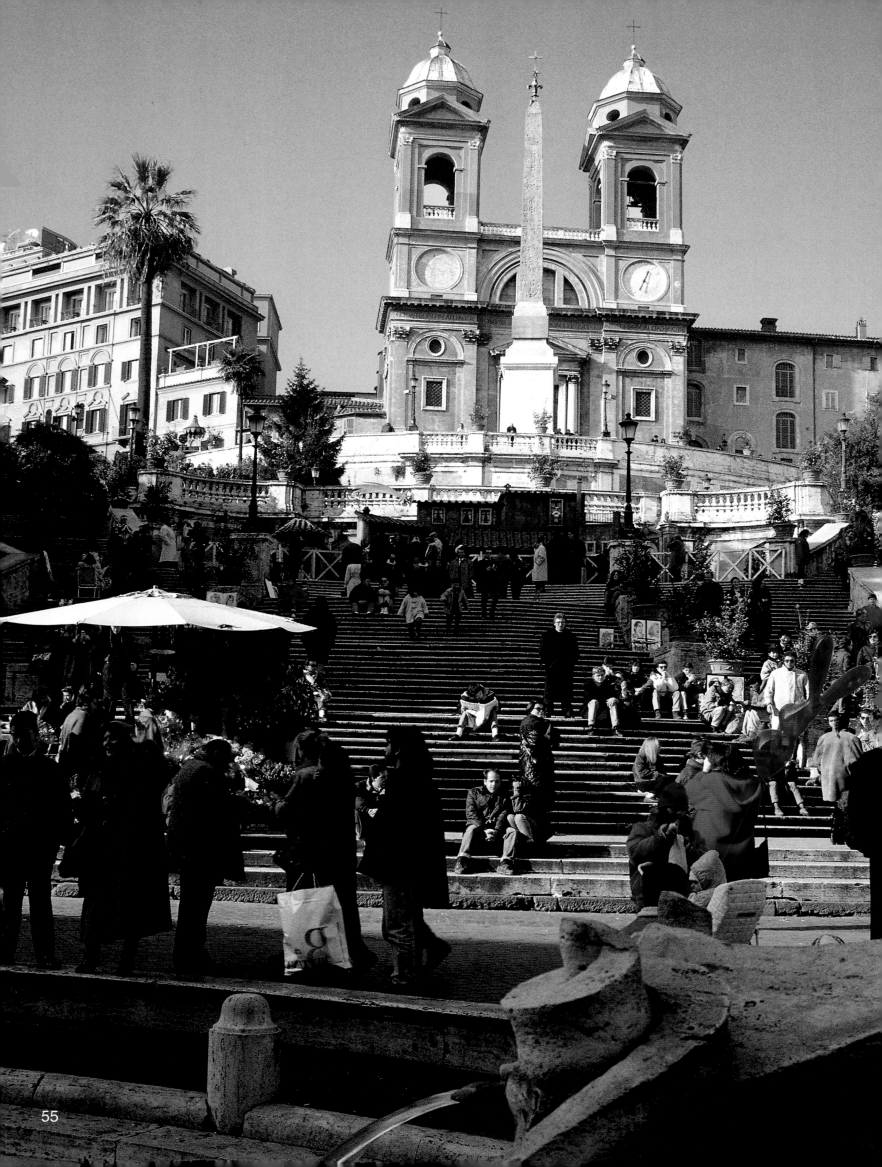

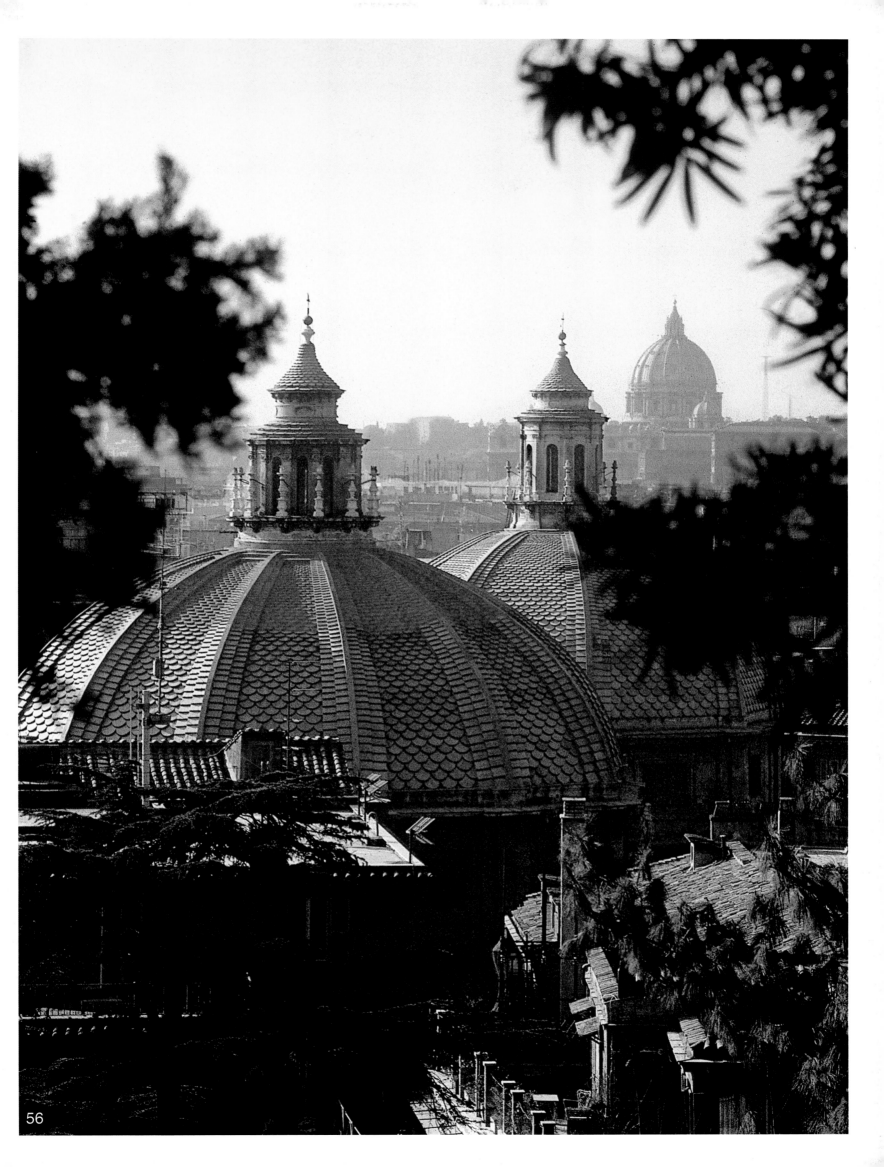

St Peter's Basilica

Turning towards the Piazza Risorgimento, it is a pleasant walk along the Via di Porta Angelica to the Piazza San Pietro and its basilica.

The first basilica was built on the orders of Emperor Constantine, on the site of the sepulchre of Peter the Apostle, near the Amphitheatre where he was martyred by Nero. The foundations were laid in AD 315 and the monument was consecrated by Pope Sylvester I in AD 326, although it was not completed until AD 349. The original basilica was of imposing dimensions, similar to those of the present edifice. It comprised five naves, separated by colonnades and preceded by a huge narthex with four porches, in the centre of which was the Cantharus, a basin used for ablutions. The Cantharus was once filled by water flowing from the great bronze pine-cone now housed in the Cortile della Pigna. The side of the fourfold porch built on to the basilica – known as 'the Paradise' – was ornamented with a mosaic, a fragment of which is kept in the Rome Museum. The bell-tower, which

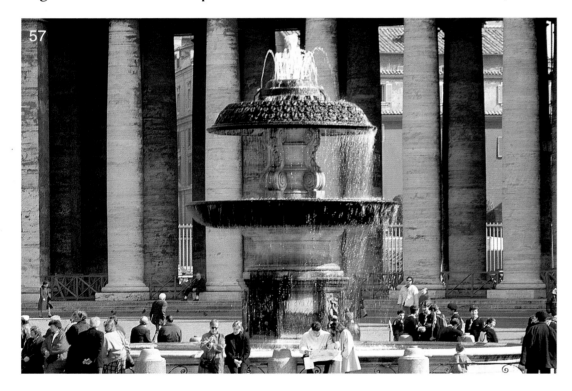

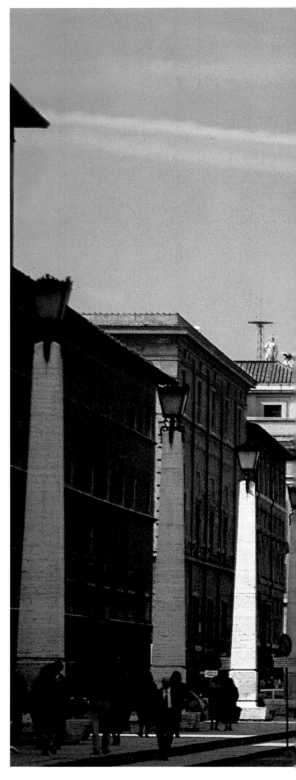

formed an integral part of the original basilica, was crowned by a golden globe and a bronze cockerel.

In the fifteenth century, Alberti advises Nicholas V (1447–1455) to restore and extend the apse of the basilica. The Pope entrusts this task to the architect Bernardo Rossellino, who draws up plans accordingly. On the death of the pontiff, however, works are suspended, and only resumed under the pontificate of Jules II (1503–1513), who decides to rebuild the basilica completely. Donato Bramante (1444–1514) takes charge of the works, which commence in 1506. Unfortunately, Jules II and Bramante both die a few years later. The original design in the form of a Greek cross is modified into a Latin cross by Raphael (1483–1520), who is appointed to take charge of the works by Pope Leo X, with the collaboration of Fra Giocondo and Giuliano da Sangallo. The design is changed once again

57. St. Peter's Square
58. Main entrance to St. Peter's Basilica
59. Cupola of St. Peter's Basilica

Next page:
60. Aerial view of St. Peter's Square
61. Interior of St. Peter's Basilica
62. Characters in St. Peter's Square
63. Aerial view of St. Peter's Square

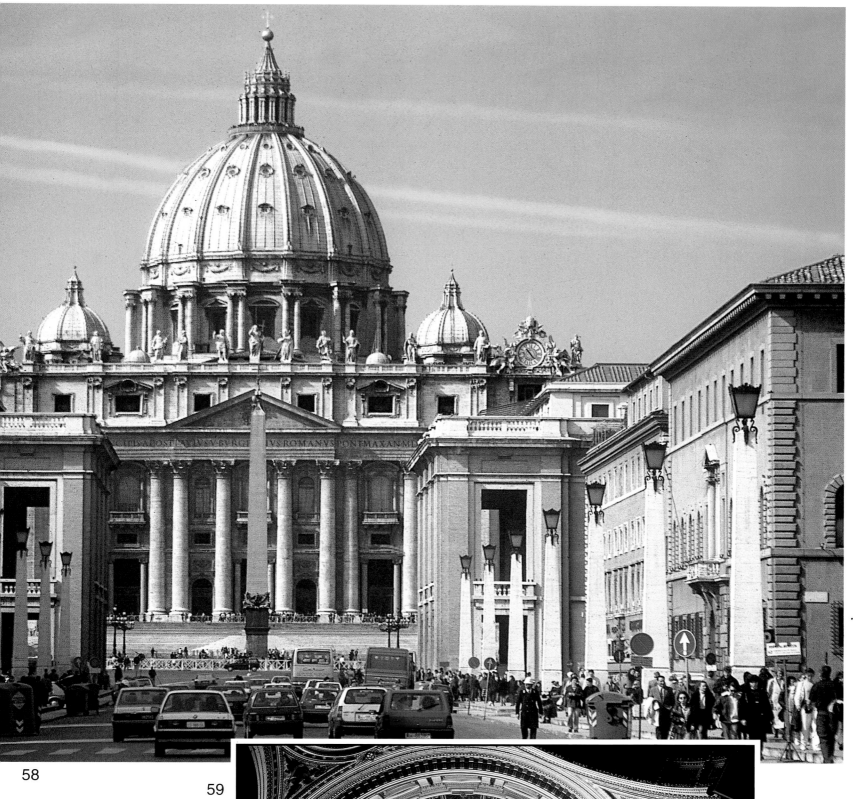

58

59

following the death of Raphael: Paul V Borghese decides on the Latin cross design. Five years before the pontificate of Paul V, tenders are invited for the renovation of the basilica's facade, and Carlo Maderno wins the commission. Works on the facade are carried out between 1608 and 1612, followed by construction of the interior porch in 1619 and the vaulted roof of the nave in 1614–1615. Initially, Maderno adheres to Michelangelo's design, but subsequently adds three chapels on each side.

Six Ionian pillars and columns are set into the walls of the narthex designed by Carlo Maderno. Above the tympanums are heads of cherubim attributed to Borromini. The ornate flooring, to a design by Bernini, is restored in 1880 under the pontificate of Leo XIII. The renovated central section commemorates the inauguration of the Vatican II Ecumenical Council under John XXIII on 11 October 1962.

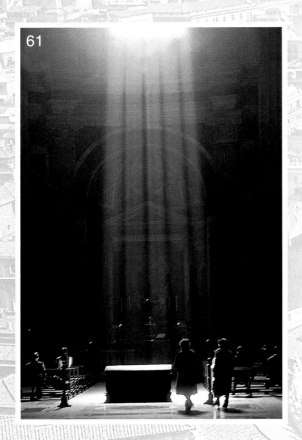

Inside the basilica, in the first chapel on the right, is the famous Pietà. This chapel, originally known as the Crucifixion, changes its name when Michelangelo's masterpiece is installed there. The marble group depicts Mary holding the dead Christ in her arms. On 27 August 1498, Jacopo Galli – who acts as an intermediary between Cardinal Jean de Bihères de Lagraulas and Michelangelo – signs the contract commissioning this work, whereby Michelangelo undertakes to create a sculpture in marble in return for a payment of 450 gold ducats from the Pope, payable on completion. Michelangelo is well aware of the value of his work: although he normally signs none of his works, he makes a point of adding an inscription to this piece. Thus we read on the strap descending from the Virgin's left shoulder: *Angelus Bonarotus Florentinus faciebat*. Vasari relates an interesting anecdote concerning this inscription: "*On entering and approaching the statue,* [Michelangelo] *found a large group of strangers admiring his work. One of them asked who had created the piece; another replied 'Bossu* [Cristoforo Solari] *of Milan'. Michelangelo kept quiet, but found it rather disconcerting to have his works attributed to someone else. One night, he shut himself in with a small lantern and his chisels, and engraved his name.*" (Vasari, *Letters*)

Pope Urban VIII consecrates the new St Peter's Basilica on 18 November 1626. Bernini (1598–1680), who takes over supervision of the works from Carlo Maderno in 1629, adds two side towers to the facade as already planned by Maderno. Bernini is succeeded by Carlo Fontana (1634–1714).

The colonnade is built under the pontificate of Alexander VII (1655–1667). This is 17 metres long, with 284 columns and 8 pillars made of travertine. Each column is 13 metres high.

The first fountain is built in the time of Pope Innocent VIII (1484–1492). In 1614, Carlo Maderno removes it and uses one of the two basins to construct a new fountain ornamented with scales. The fountain is installed to one side of the obelisk, breaking the symmetry with the basilica's facade. During works carried out in 1667 under Bernini's supervision, Maderno's fountain is removed and replaced – with various modifications – in line with the

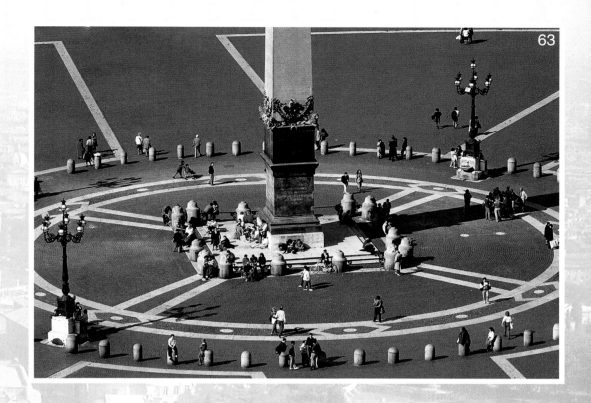

obelisk. In 1677 a second, symmetrical fountain is built, inspired by different motives.

A great, uninscribed, monolithic obelisk square made of red granite rises in the centre of the square. Pliny the Elder mentions this monument in his *Natural History*. The obelisk is 25.31 metres high, with a base measuring 8.25 metres. In 1586, Pope Sixtus V moves it to the centre of the square, under the supervision of Domenico Fontana. Pope Innocent XIII (1721–1724) adds the bronze eagles, inspired by his family's coat of arms. Finally, Pius IX completes the ornamentation of the square with the four candelabra designed by Sarti (1852).

The paving of the square features the sundial and compass rose created in 1817 by the astronomer Gilij, using the obelisk as the gnomon. At the foot of the basilica's steps are statues of Peter and Paul by Fabris and Tadolini, originally designed for the new basilica of San Paolo Fuori le Mura. The statues were installed in St Peter's Square by Pius IX in March 1847.

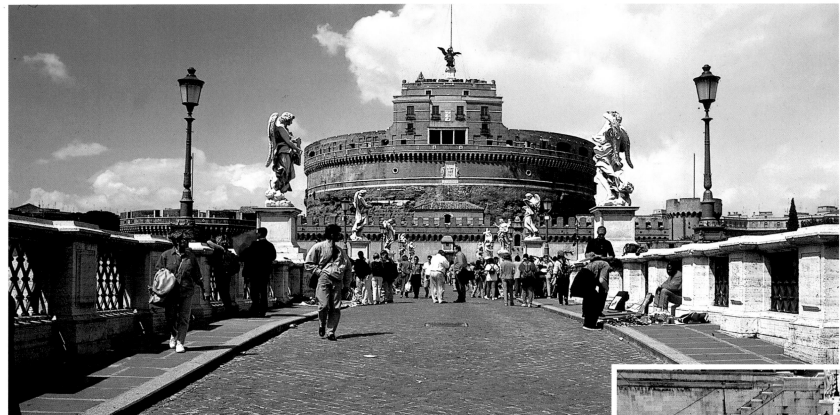

64

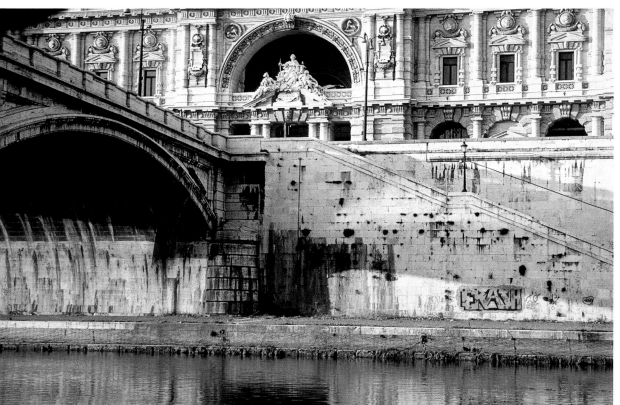

65

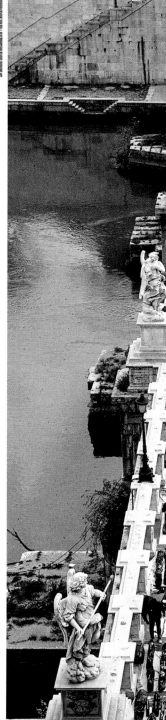

64. Ponte Sant'Angelo (Bridge of the Angels)
65. Humbert Bridge, view from the Tiber
66. Isola Tiberina (Tiber Island)
67. Ponte Sant'Angelo
68. View of Castel Sant'Angelo from the Tiber

Castel Sant'Angelo and Ponte Sant'Angelo

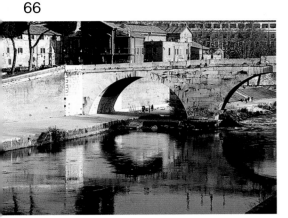

66

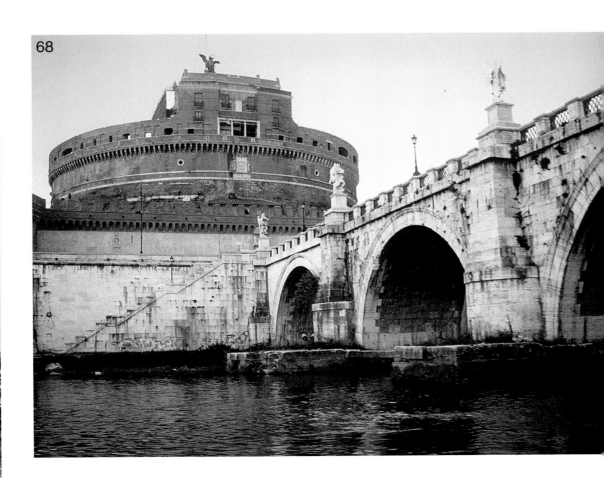

67

From the Piazza San Pietro, we take the majestic Via della Conciliazione to Lungotevere di Castello, site of the impressive tomb of the emperor Hadrian, known as Castel Sant'Angelo. This fortress served as a prison for rebellious nobles and priests, and was used for the incarceration of the *Carbonari* during the nineteenth century.

Although Stendhal speaks of the fortress in very romantic terms, the prisons of Castel Sant'Angelo were extremely harsh in reality. The old name for the monument was *Hadrianeum*, since Hadrian intended it as a mausoleum for himself and his descendants. This colossal edifice, begun in AD 123, received the remains of Roman emperors until AD 217, when Caracalla died at the hands of Macrinus.

In order to provide access to the fortress, Hadrian builds the Pons Aelius. The bridge is renamed Ponte Sant'Angelo after it is transformed into the Baroque style by the genius of Bernini, who embellishes it with ten statues of angels bearing symbols of Christ's Passion. At the entrance to the bridge, there are two statues of the Princes of the Apostles, commissioned by Clement VII in 1534. These replace the two propitiatory chapels built by Nicholas V after the inundation of the bridge on 14 December 1449. Today, the old fortress houses the Castel Sant'Angelo National Museum, which was renovated 1993 and is open to visitors daily.

68

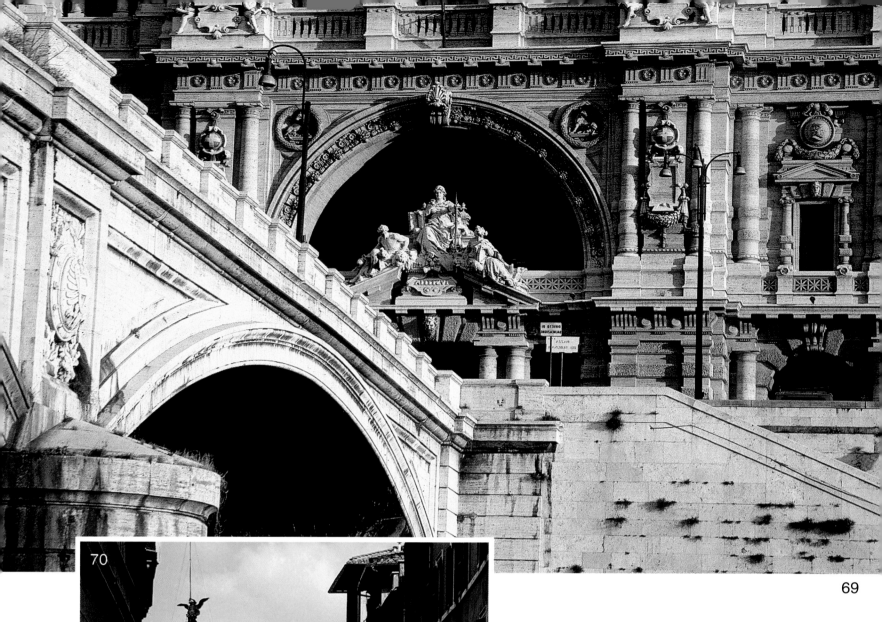

69

70

69. Humbert Bridge and the Palace of Justice
70–72. Castel Sant'Angelo

Next page:
73. Ponte Sant'Angelo
74. View of Vittorio Bridge from the Tiber

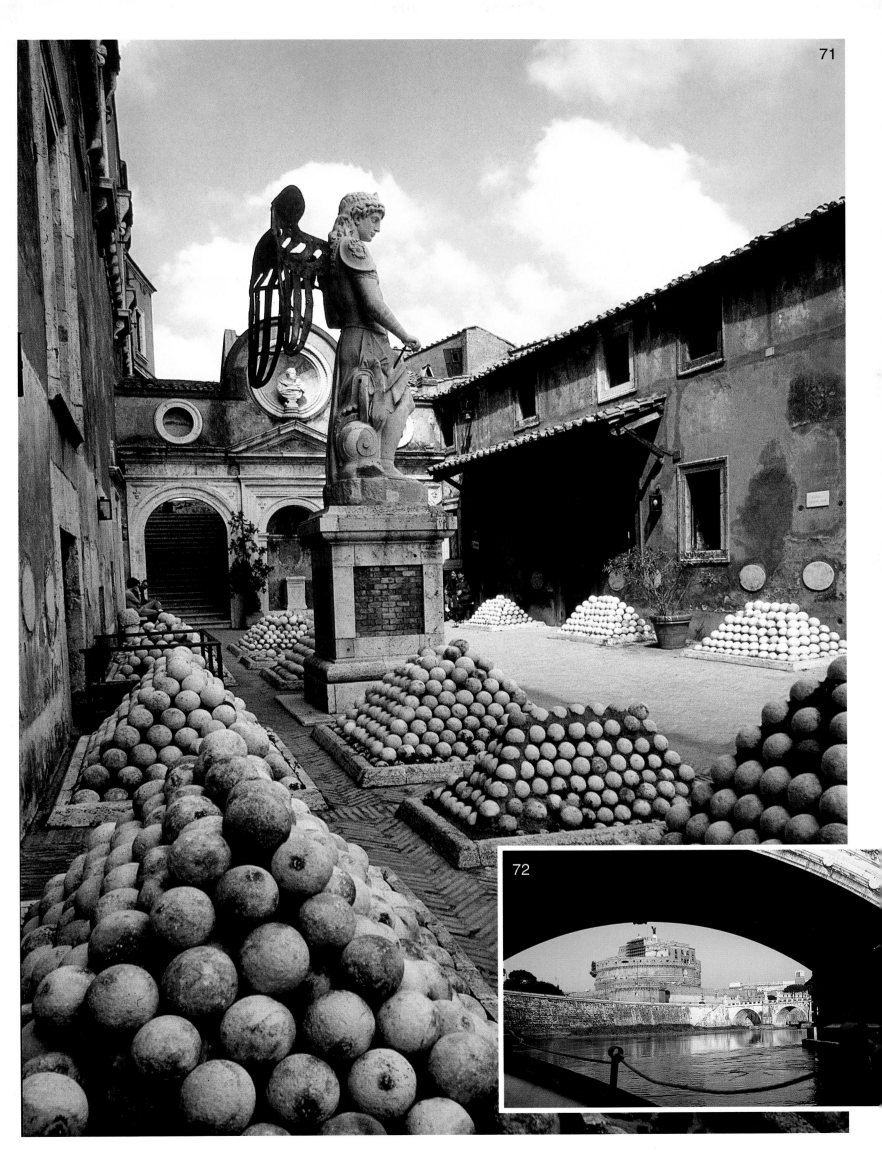

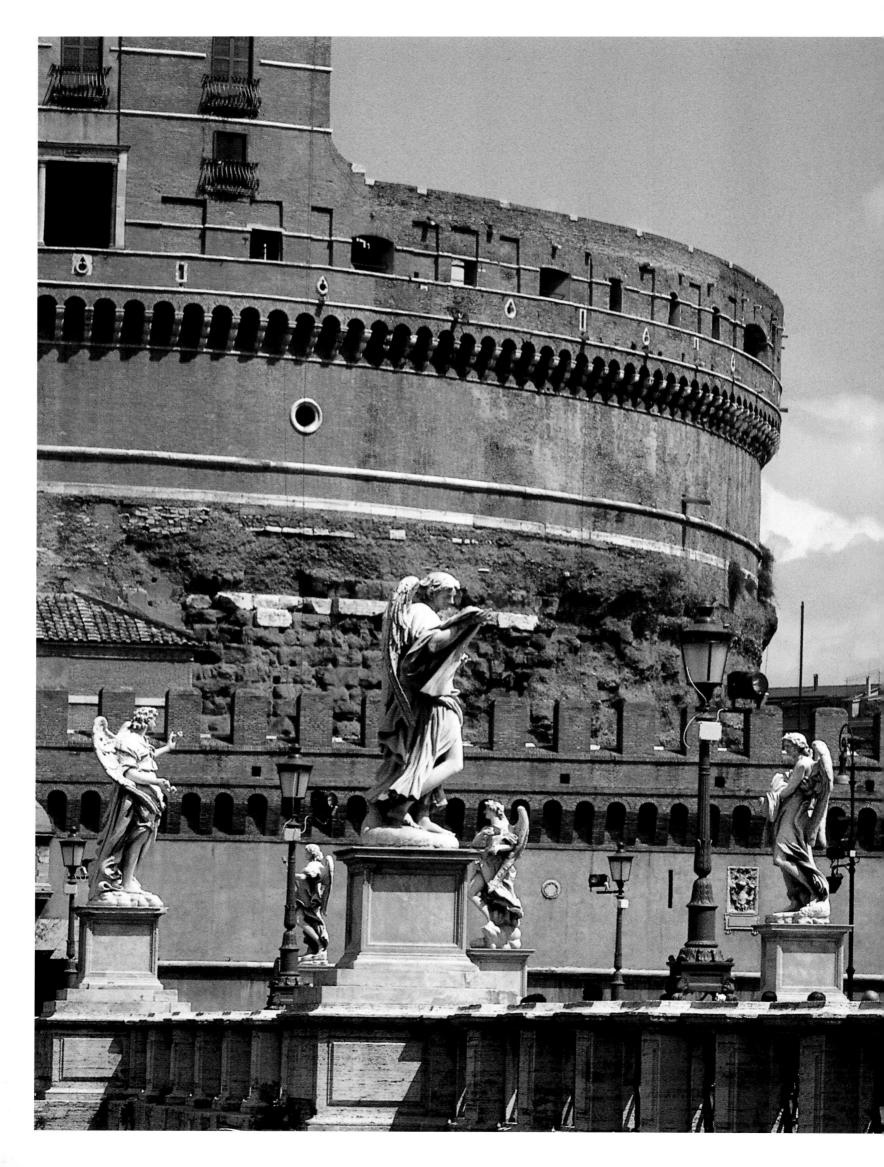

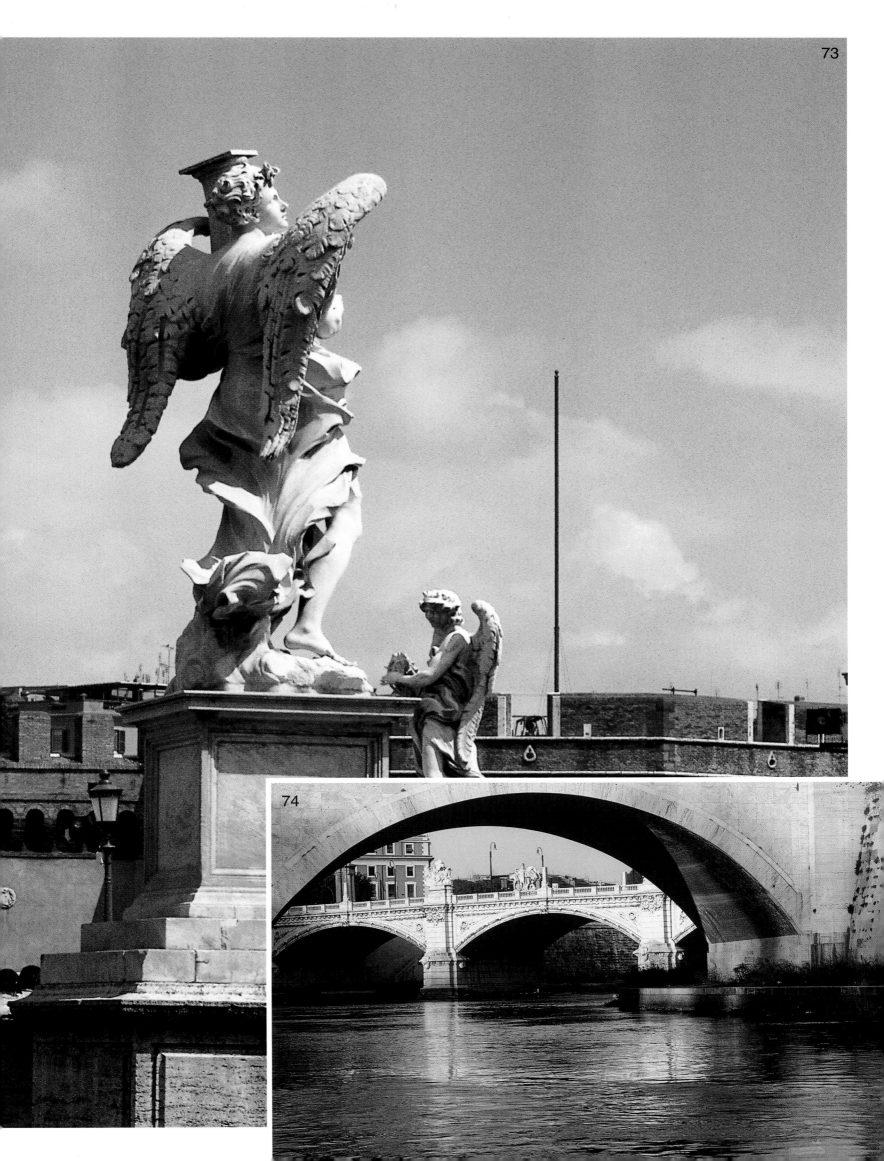

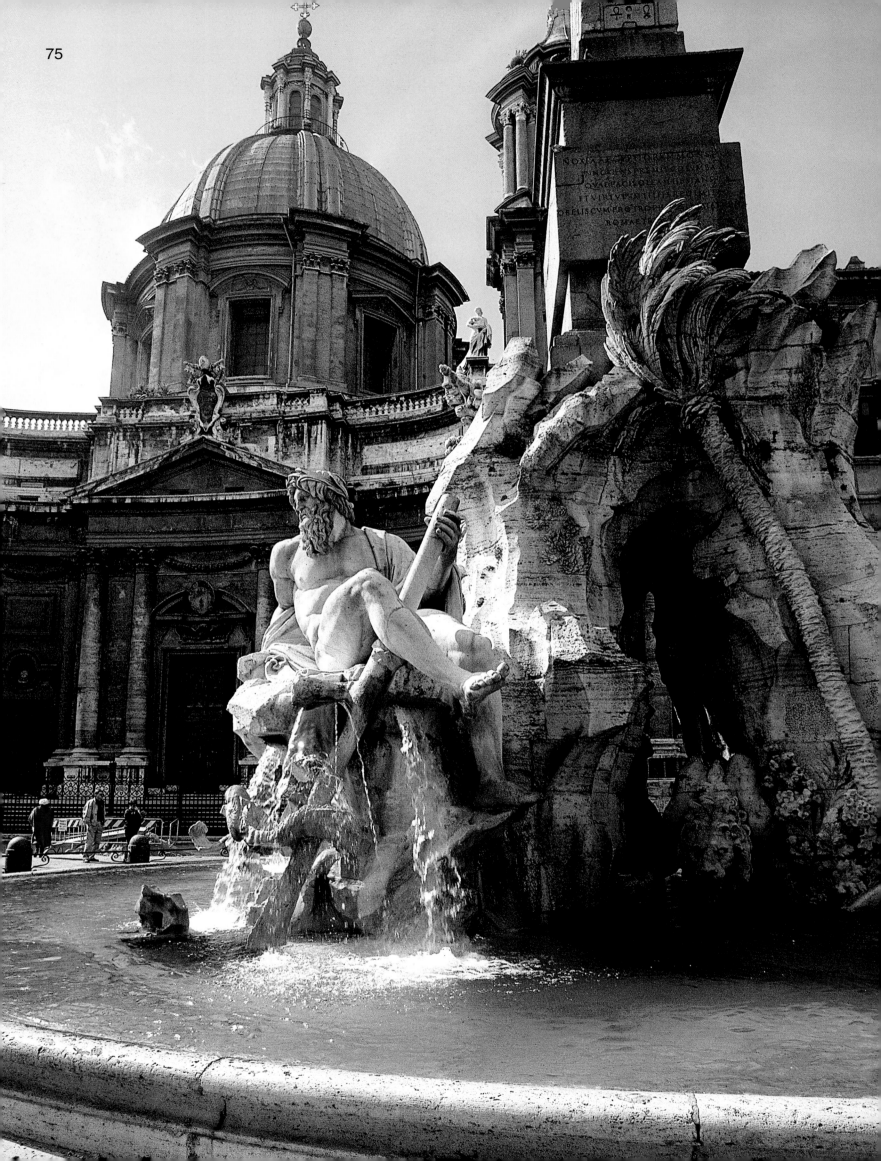

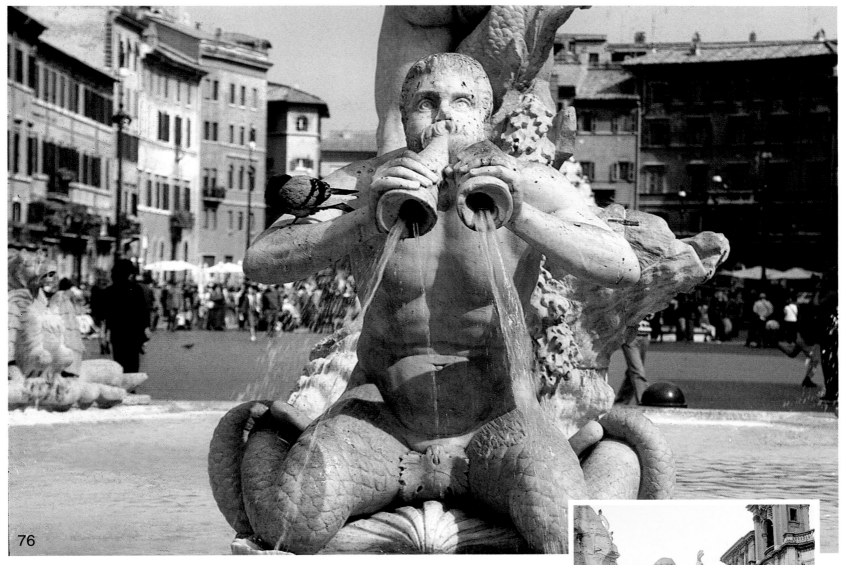

76

Piazza Navona

Crossing the Sant'Angelo bridge, we come to the square of Ponte Sant'Angelo. From here, we set off down the Via del Banco di Santo Spirito until we reach the Via dei Banchi Nuovi. Crossing this street brings us to the Piazza dell'Orologio, where we find the start of the Via del Governo Vecchio, which in turn leads us to the Piazza Pasquino. If we now walk down the Via del Pasquino, we will see the famous 'talking statue', where the celebrated Pasquino used to launch his attacks on the governing classes in the form of dialogues. The street then gives on to the majestic Piazza Navona, a perfect example of Baroque architecture – perhaps one of the most representative sites anywhere in the city.

The square was originally marked out by a simple wooden balustrade, designed to enclose the gymnastic games under Caesar and Augustus. The emperor Domitian built the stadium in approximately 86 AD to hold some 30,000 spectators.

Several oratories were built in the stadium during the eighth century, to be joined in the mid-thirteenth century by residential buildings.

77

75, 76. Piazza Navona
77. Piazza Navona,
fontana dei quattro fiumi
(Fountain of the Four Rivers)

With the advent of the Renaissance, the square's appearance changed dramatically. Houses, palaces and churches were built, and in 1477 the market was moved here from the Capitol.

The square is ornamented by three magnificent fountains arranged along its median line. Arriving from the Via Pasquino, we come first to the Fontana del Moro, which takes its name from the statue of an Ethiopian fighting a dolphin. The piece was created in 1654 by the sculptor Giovanni Antonio Mari to a design by Borromini. The second, central fountain, magnificent and majestic, is known as the Fontana dei Fiumi, and was built in 1651. The fountain is crowned with an obelisk taken from the Maxentius amphitheatre, and is another product of Bernini's genius. At the corners of the monument's base, which features a lion and a horse drinking from the water, are four personifications of the Nile, Danube, Ganges and La Plata rivers. Popular tradition attributes a curious feature to this allegory. It is said that if one looks closely at the statue's hand, one notices that it is at the level of its eyes, as though to protect itself against something about to fall on it, or to shield itself from some dreadful sight. Opposite the fountain is

78

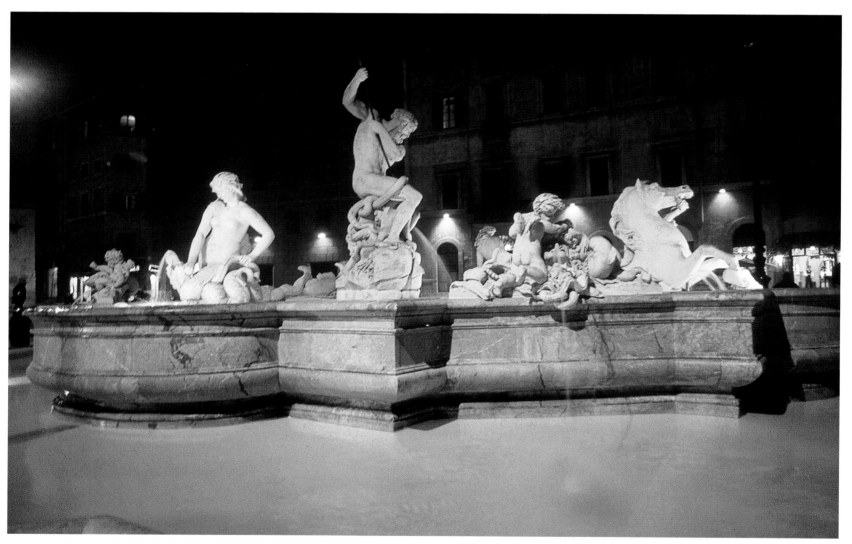

79

the beautiful church of Sant'Agnese in Agone, on the site where the saint was stripped naked and pilloried. The church was begun in 1652 by Carlo Rainaldi and completed in 1657 by Francesco Borromini. According to tradition, relations between Borromini and Bernini were bad.

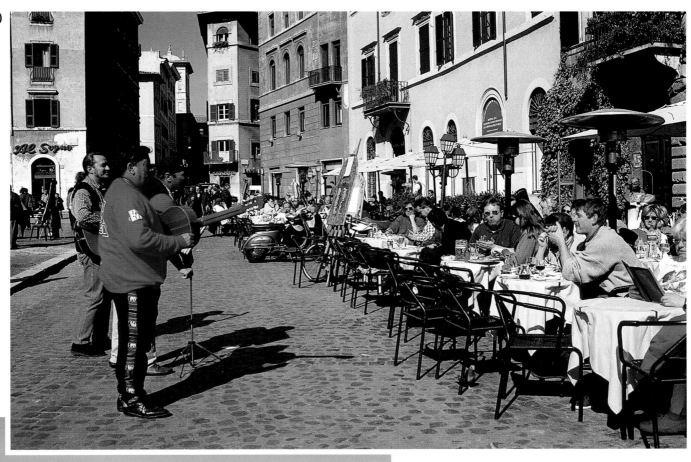

80

81

82

78–82. Piazza Navona

Next page:
83. Piazza Navona, Fontana del Nettuno
(Neptune Fountain)

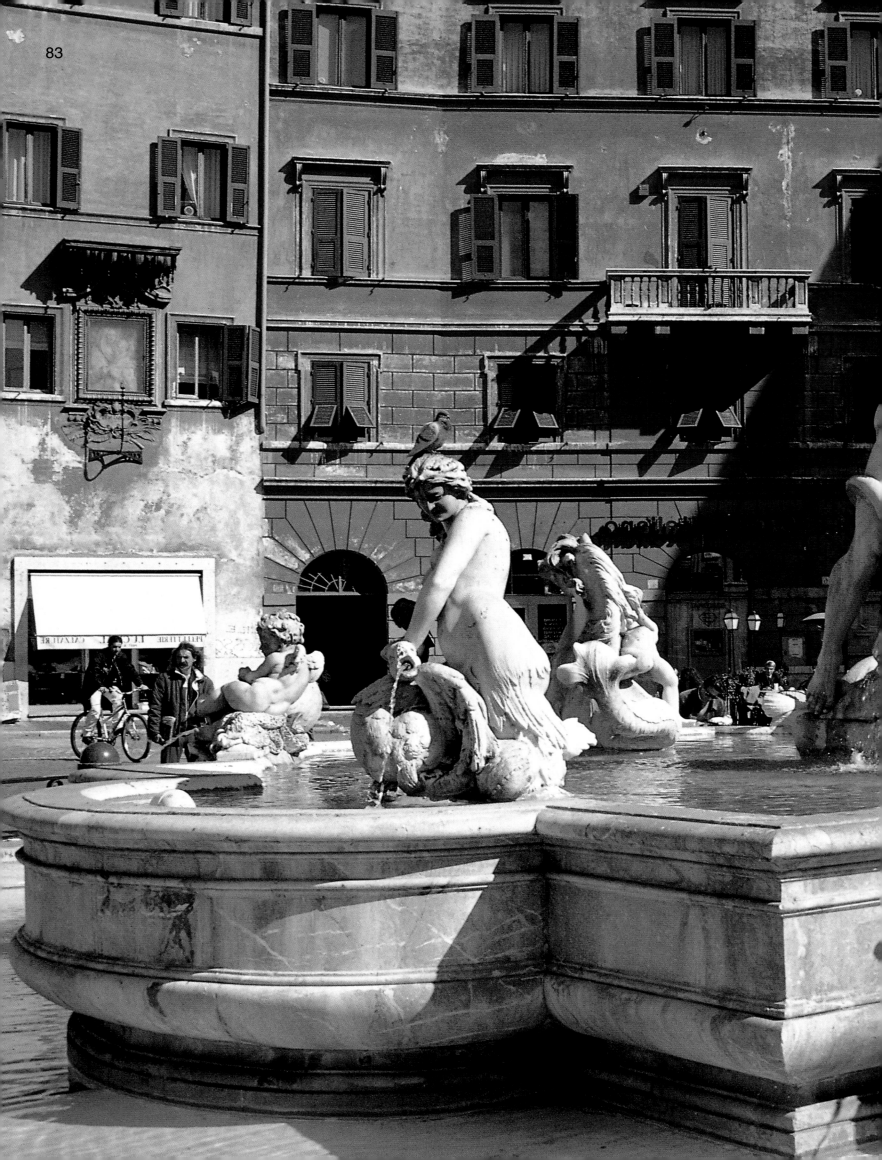

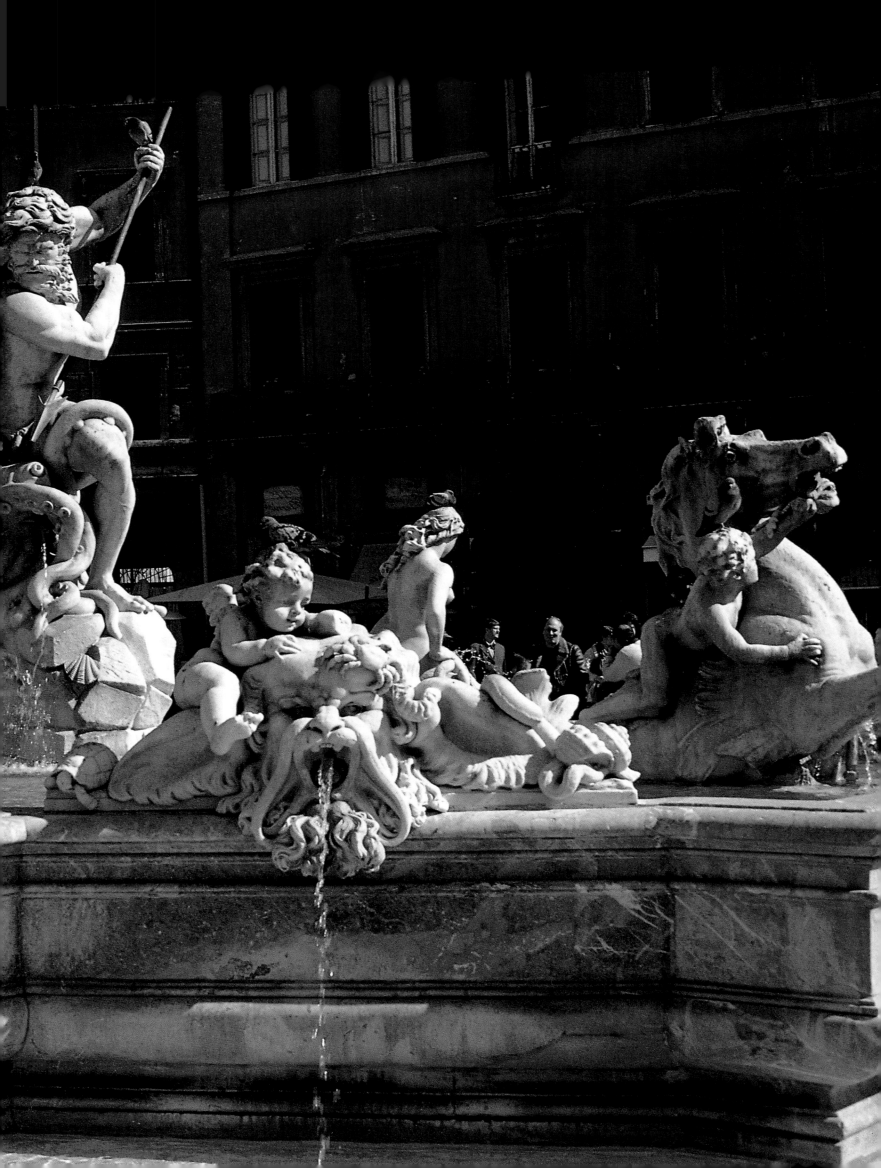

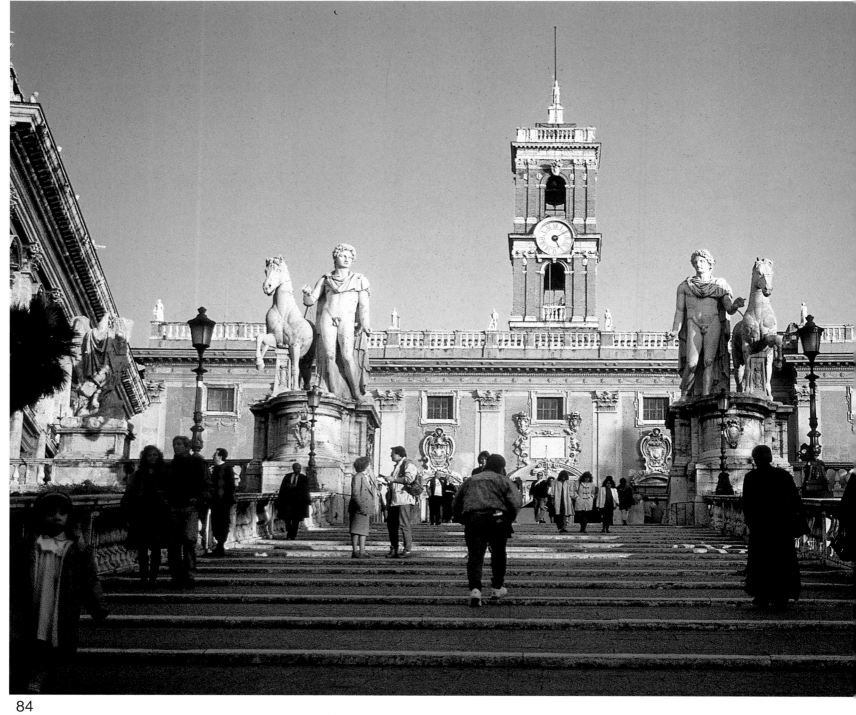

84

85

Piazza Venezia, Altare della Patria and the Capitol

After returning to the Piazza Pasquino, we take the Via della Cancelleria to rejoin the Corso Vittorio Emanuele II, which leads us to the Piazza del Gesù, home of the splendid church of the same name. We then follow Via del Plebiscito to the Piazza Venezia. This square takes its name from the Palazzo Venezia, regarded as Rome's finest work of Renaissance civic architecture, which now houses the thirty exhibition rooms of the Palazzo Venezia Museum. The south corner of the square is dominated by the monument to Vittorio Veneto, also known as Altare della Patria or Vittoriano. The project was begun in 1885 by Giuseppe Sacconi, and construction took over fifty years. The monument celebrates the memory of King Victor Emmanuel II.

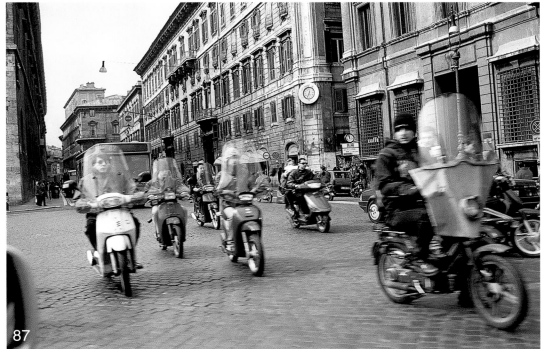

87

86

The first stone was laid by Humbert I, and Victor Emmanuel III presided over the inauguration on the five-hundredth anniversary of the unification of Italy. However, work was not completed until 1935. Behind this imposing monument lies the Capitol.

From the very earliest times, the Capitol serves a fortress on one of the most ancient sites of Rome. After the fires of AD 69 and AD 80, it is definitively restored by the emperor Domitian. Subsequently abandoned for some time, with the land given over to pasture, it is then rehabilitated by the construction of various buildings which, in turn, are replaced by the architecture of Michelangelo. The Palazzo dei Senatori (1568) and the Palazzo dei Conservatori (1655) are built to designs by Michelangelo. He also creates the balustrade, although this (along with both palaces) is subsequently modified by Della Porta, Guidetti and Rainaldi. The two palaces house the collections of the Capitol Museums, rich in classical sculptures, some of which are extremely valuable. The Palazzo dei Conservatori is the home of the famous Capitol she-wolf, a bronze sculpture

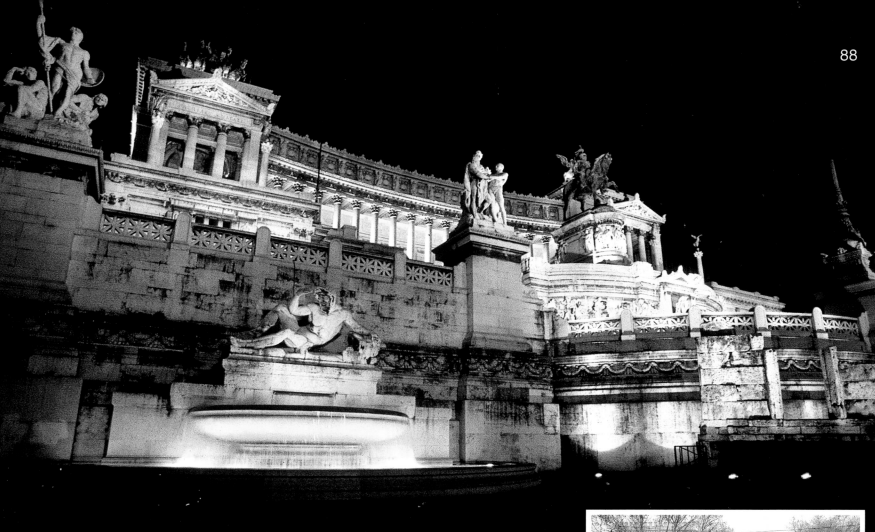

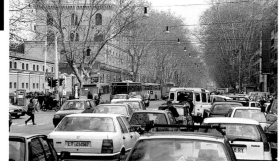

dating from the beginning of the fifth century BC. In the fifteenth century, this is adopted as the emblem of the city, recalling as it does the legend of Romulus and Remus.

However, the figures of the twins being suckled by the wolf are from a later period. They were created during the fifteenth century by a Florentine artist, almost certainly Antonio Benci, also known as Pollaiolo (1431–1498). In 1585, the statues of the majestic Dioscurides are removed from the temple dedicated to them and installed beside the staircase.

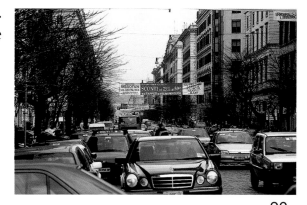

88. Vittoriano – Victor Emmanuel II monument
89. Via Giulio Cesare
90. Via Cola di Rienzo
91. Via Giulio Cesare
92. Vittoriano

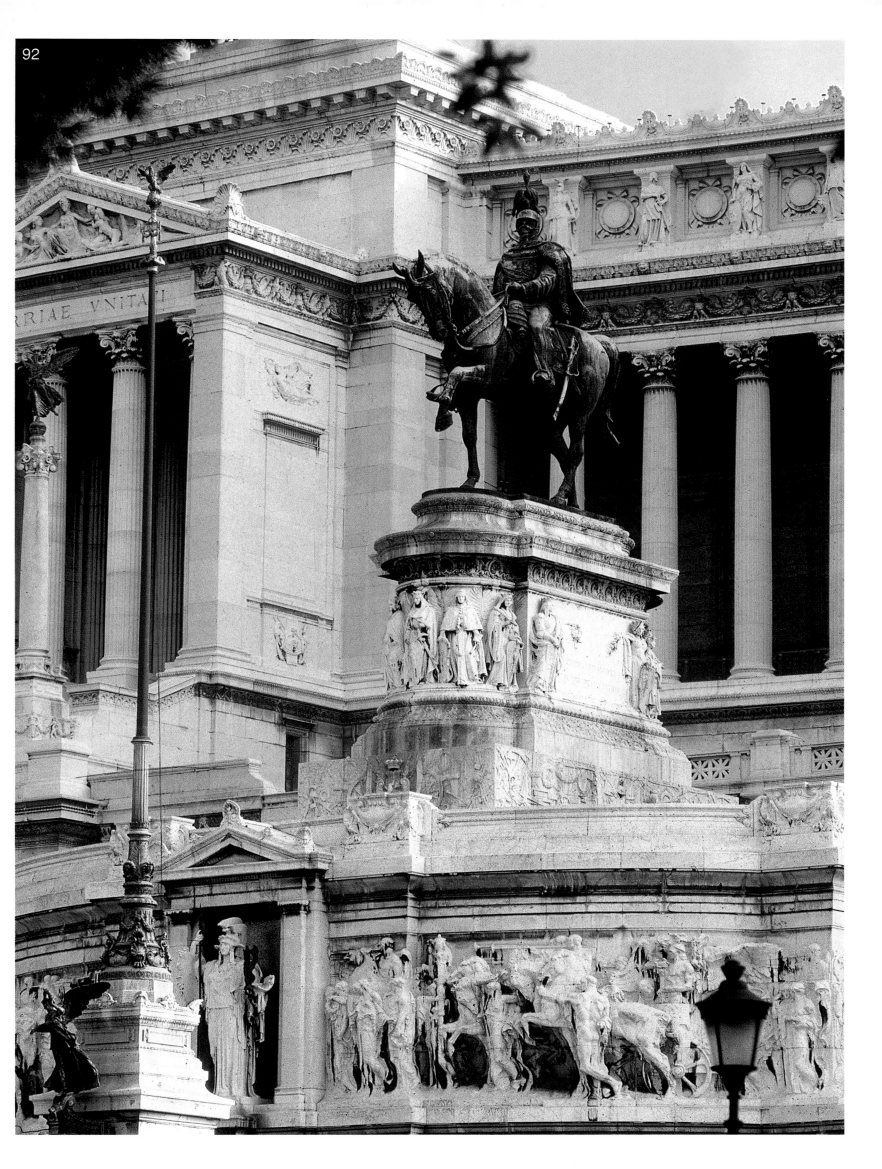

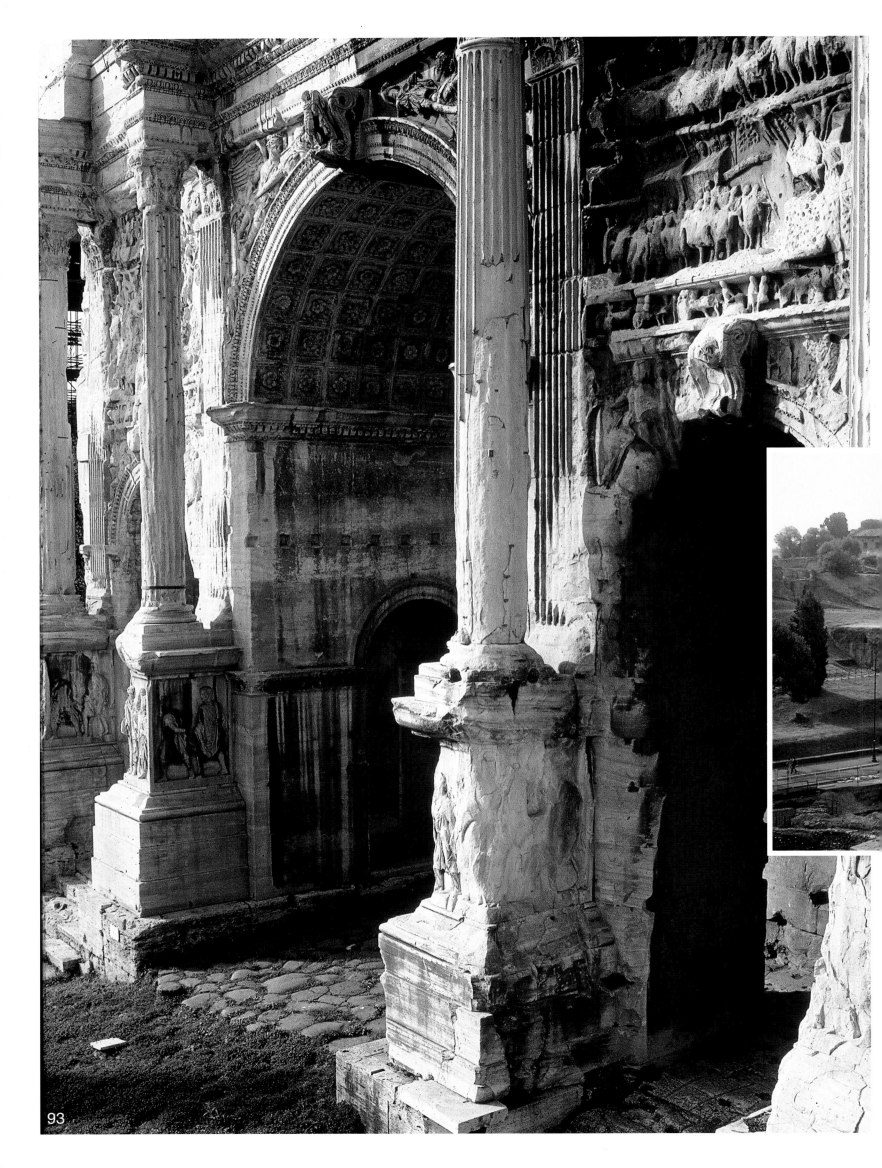

Fori Imperiali

From the Piazza Venezia, we move on to the Via dei Fori Imperiali. The present architecture here dates from the fascist period of 1931–1933. This area is known as the Fori Imperiali because five forums were built here from the time of the Caesars onwards. With the coming of the republican era, the Forum was no longer sufficient, so Julius Caesar built a new forum in an area which already contained private residences.

Augustus built a further forum in 32–31 BC, as did Vespasian in 71–75 BC, followed by Nerva in 98 BC and Trajan in 107–113 BC. This ensemble, one of the most extensive in the whole of ancient Rome, occupied 1200 m².

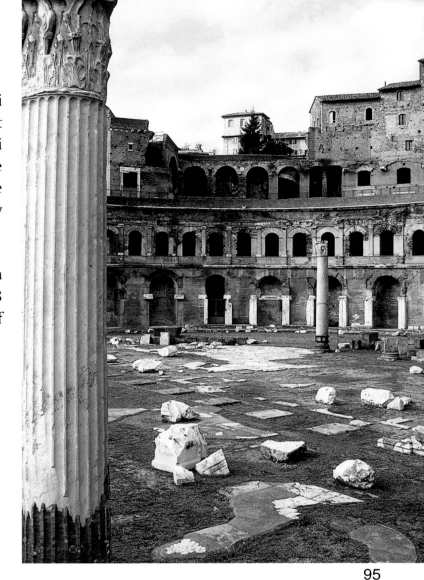

94

95

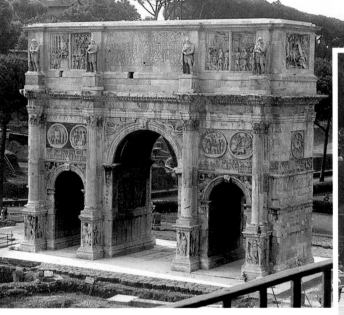

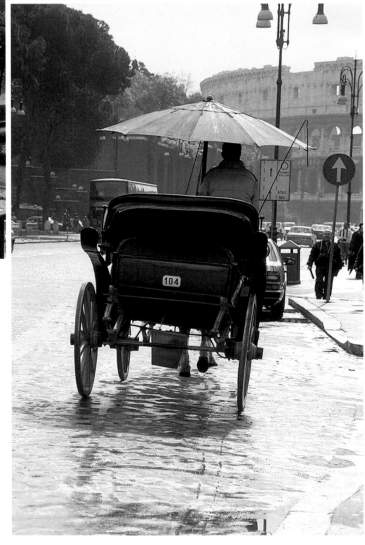

93. Forum – Triumphal Arch by Septimius Severus
94. Forum Romanum
95. Forum – mercati Traiani (Trajan's market)
96. Via dei Fori Imperiali

Next pages:
97, 98, 99. Forum Romanum
100. Forum – Triumphal Arch by Septimius Severus

96

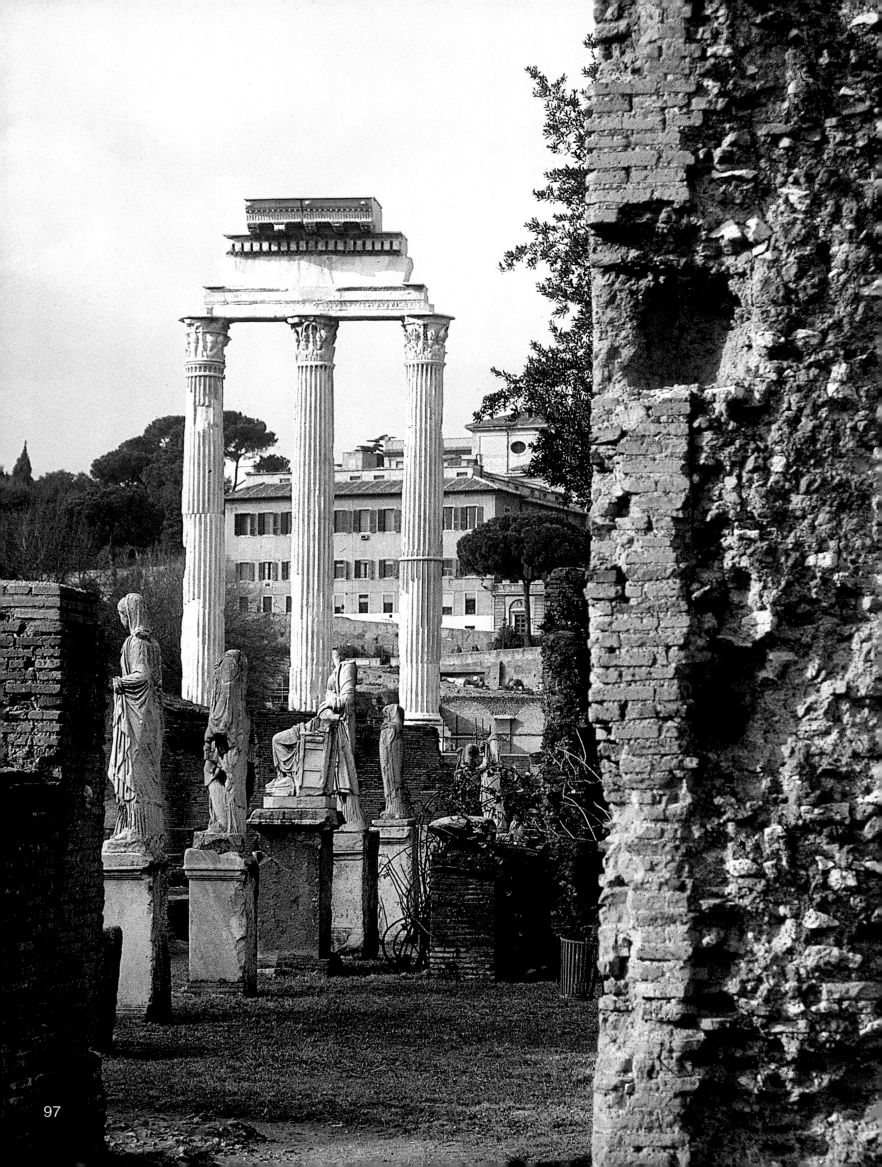

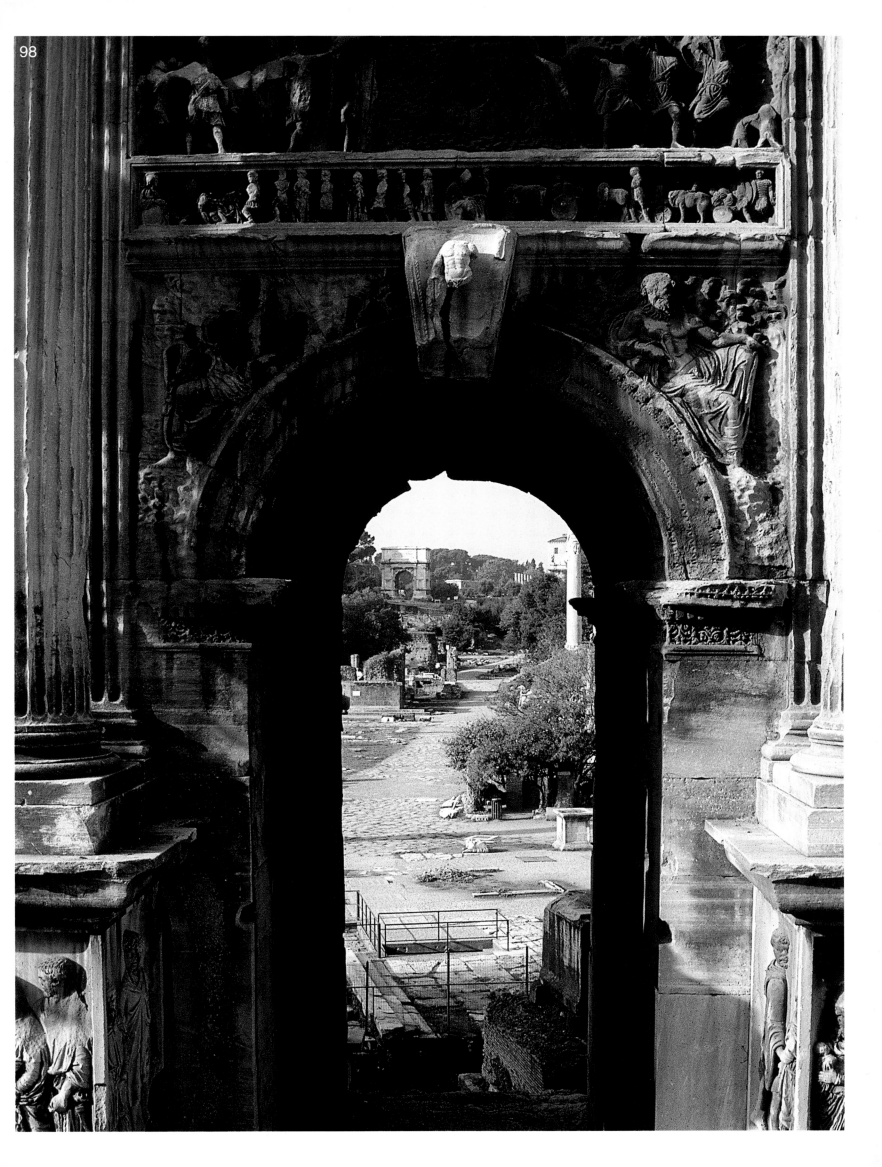

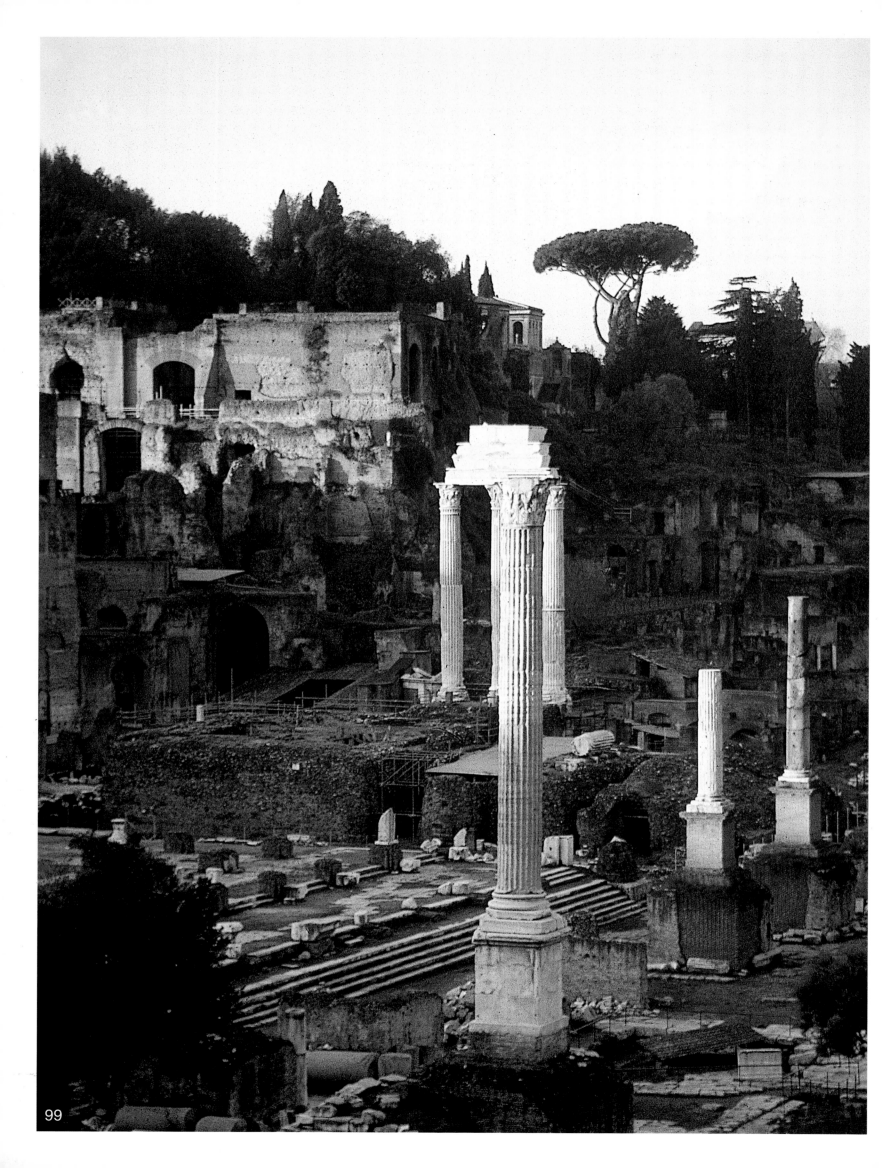

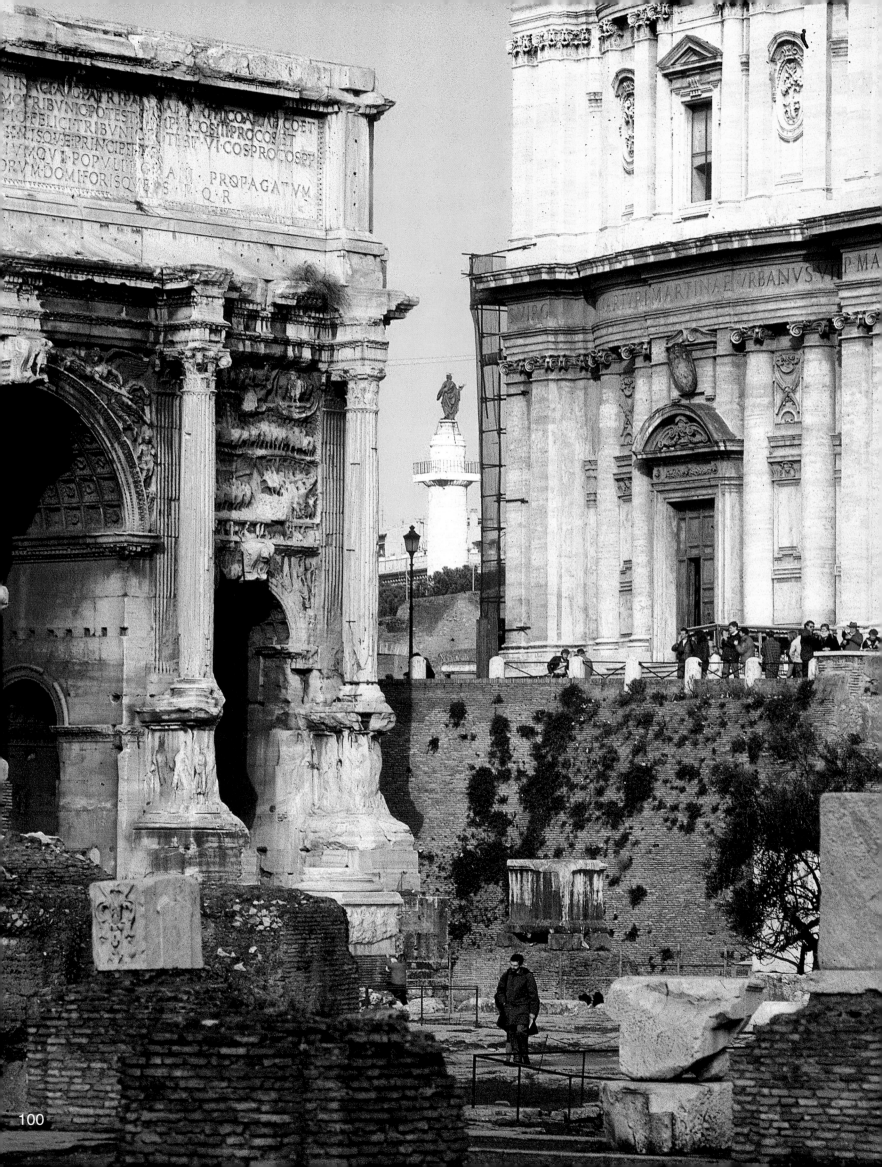

The Colosseum

At the end of the Via dei Fori Imperiali, we come to the Flavian amphitheatre known as the Colosseum since the Middle Ages on account of the colossal statue of the emperor Nero.

The Colosseum is the emblem of the City of Rome. The great amphitheatre is built during the rule of the Flavian dynasty. Works begin under Vespasian in AD 75 and are completed during the reign of his sons Titus and Domitian. It is inaugurated by Titus in AD 80, and the celebrations last 100 days without interruption. The upper part is completed under Domitian.

The Colosseum is 48.25 metres high, enclosing an arena of 86 x 54 metres, and in its day was capable of accommodating 50,000 people. The public came here to watch bloody spectacles featuring the gladiators for whom the edifice was designed. Three different orders of traventine arches can still be seen on three tiers: Doric, Ionian and Corinthian. Pope Benedict XIV consecrated the amphitheatre to the Passion of Christ and the memory of the Christian martyrs who died here, and built the fourteen Stations of the Cross around the perimeter of the arena. The most recent restoration project was started in 1992.

101. Thermal Baths of Caracalla
102. Arch of Constantine
103. Colosseum

Next page:
104. Colosseum
105, 106. St. Sebastian's Catacombs

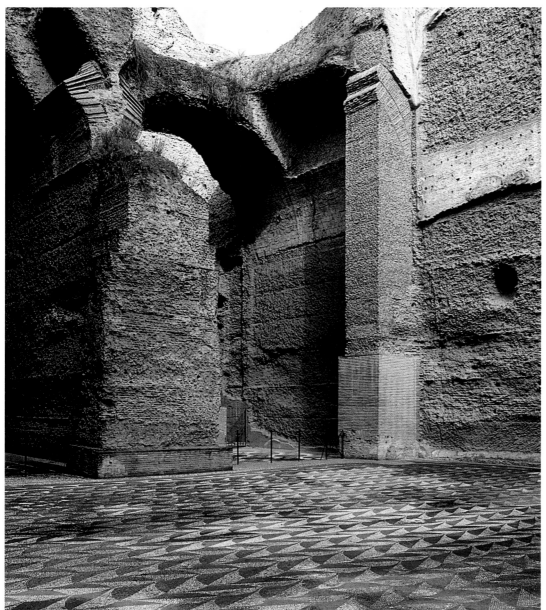

101

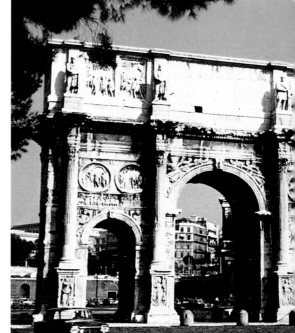

102

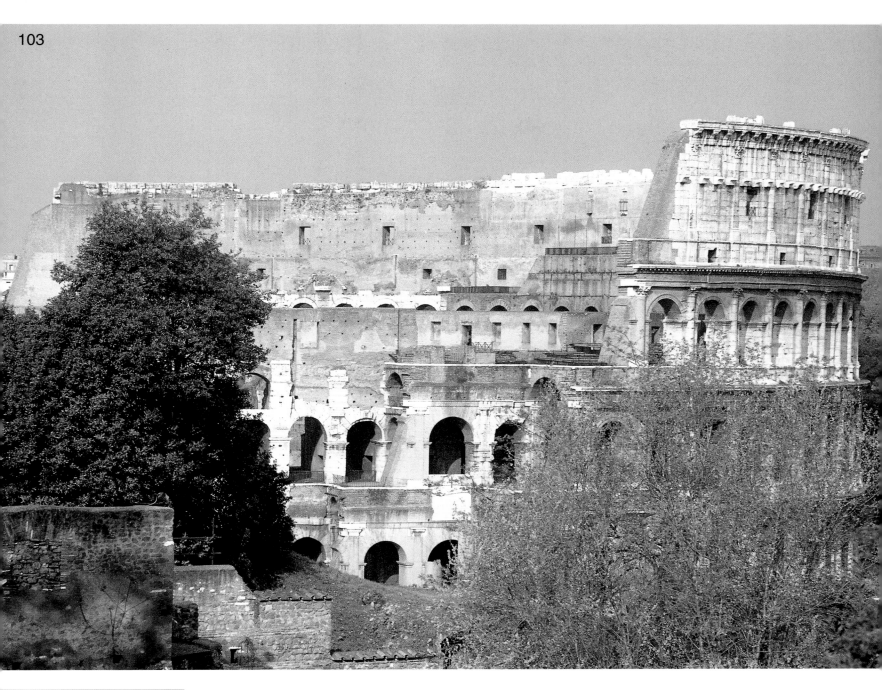

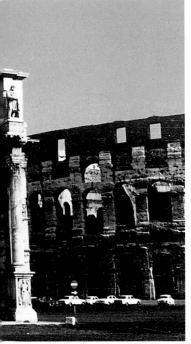

The Arch of Constantine

Looking towards the Colosseum from the Via San Gregorio, we see the magnificent Arch of Constantine on our left. This was built in 315 AD following a decision by the Senate and the Roman people to honour the memory of the emperor and his victory over Maxentius. Marcus Aurelius Valerius Maxentius (around AD 275–312), Roman emperor, son of Maximilian, was excluded from the succession and withdrew into private life when his father and Diocletian abdicated in 305 AD. However, when Constantine was proclaimed emperor, the Praetorian Guard – who vigorously disputed the proclamation – elected Maxentius in his stead. Confident of the power invested in him by the emperor's official guards – who we know intervened in Rome's political affairs on numerous occasions – he confronted Constantine on the Milvius bridge, only to be defeated and put to death. During the Middle Ages, the Arch of Constantine was incorporated in the fortifications of the noble Roman Frangipane family. A major restoration was carried out in the eighteenth century. The most recent restoration was in 1981–1987.

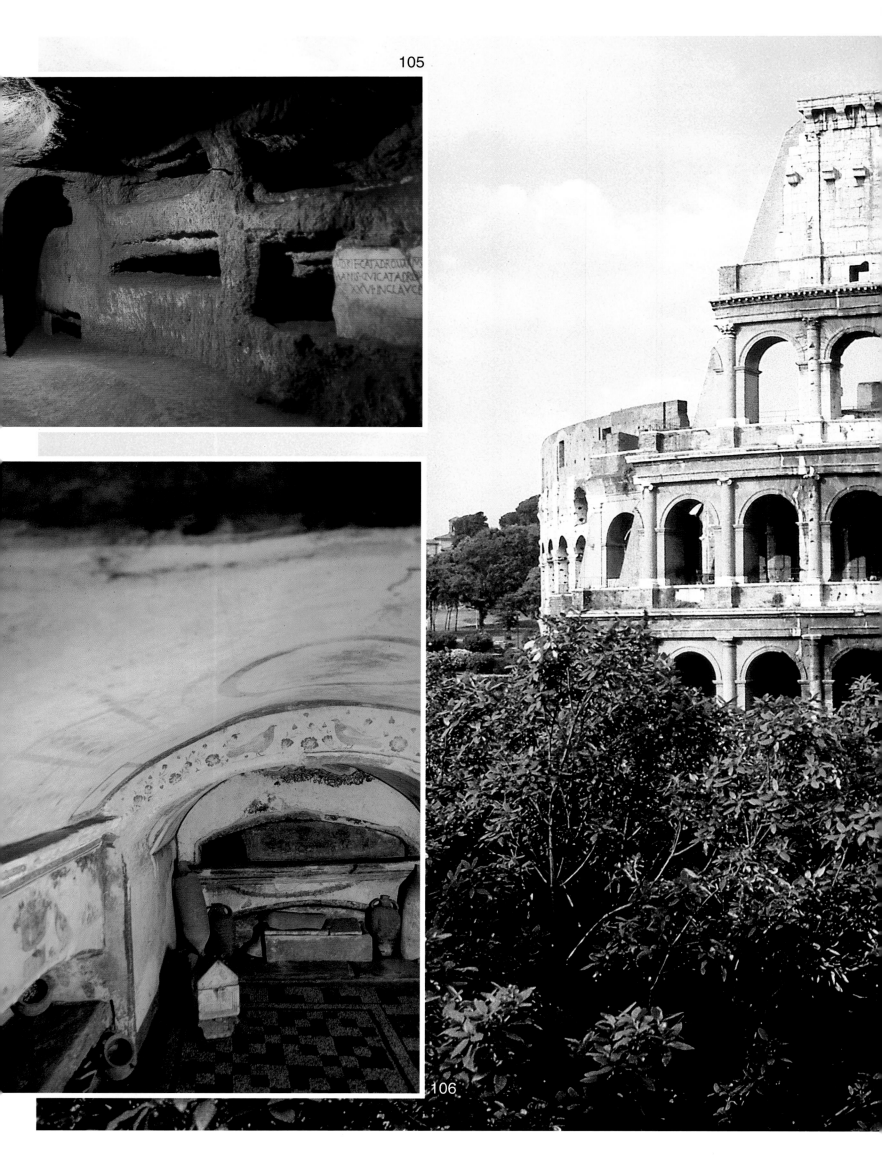

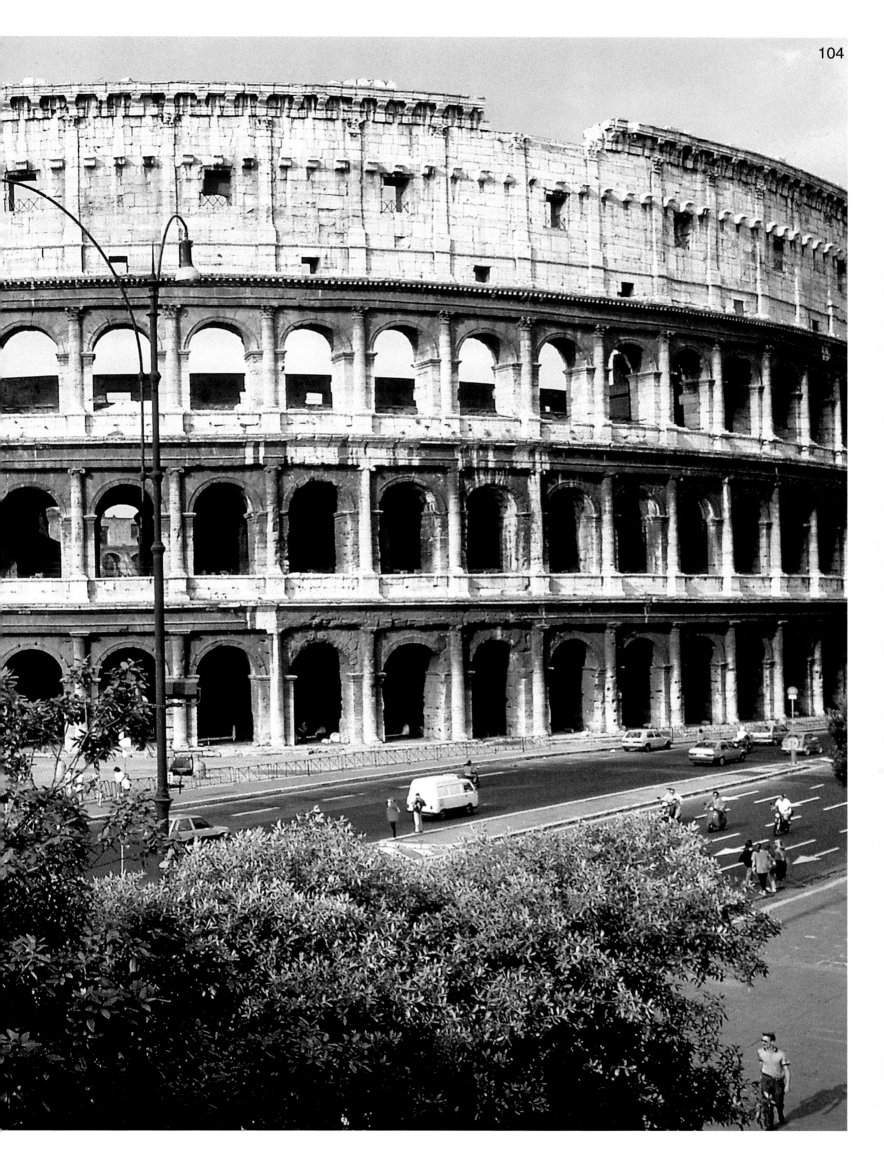

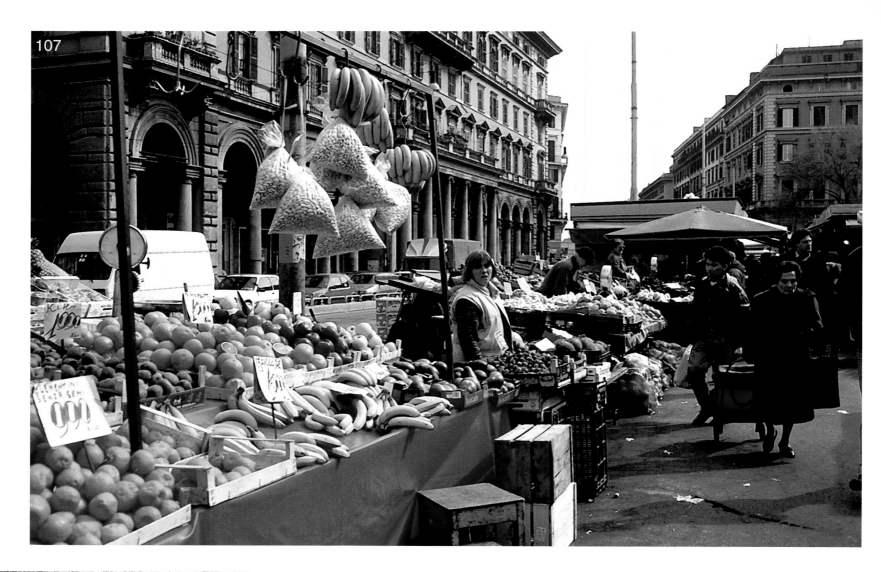

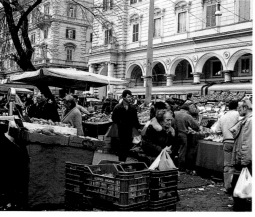

108

107, 108. Piazza Vittorio Emanuele (Victor Emmanuel Square)

109. Porta Maggiore

Next page:

110. Piazza di Porta Maggiore (Porta Maggiore Square)

111. Basilica di San Lorenzo (St. Laurence's Basilica)

112. Piazza di Porta Maggiore

The Basilica of Santa Maria Maggiore

From the Colosseum, we take the Via dei Fori Imperiali to the Largo Ricci, where the great Via Cavour begins. After walking some way along this street, we arrive at the Piazza Esquilino, site of the majestic basilica of Santa Maria Maggiore.

According to the *Liber pontificalis*, the building of the basilica is commissioned by Sixtus III (432–440). The Pope consecrates it to the Blessed Virgin after the Council of Ephesus (431) declares that Mary may be called Mother of God (Theotokos). Nicholas IV (1288–1292) renews the apse and Clement X the main facade. Between the fifth and eighteenth centuries, various modifications and additions are made: the transept and a new apse in 1200, the 'Oratorium ad praesepe' in 1290, the porch mosaics in 1300, the bell-tower (which, at 75 metres, is the highest in Rome) in 1377, the ceiling by the architect Giuliano da Sangallo around 1400, the designs for the Sforza Chapel by Michelangelo, reworked by Giacomo della Porta between 1564 and 1573, the Sistine Chapel between 1605 and 1611, and finally the baldachin of the high altar and the monumental facade, which are completed in the mid-eighteenth century.

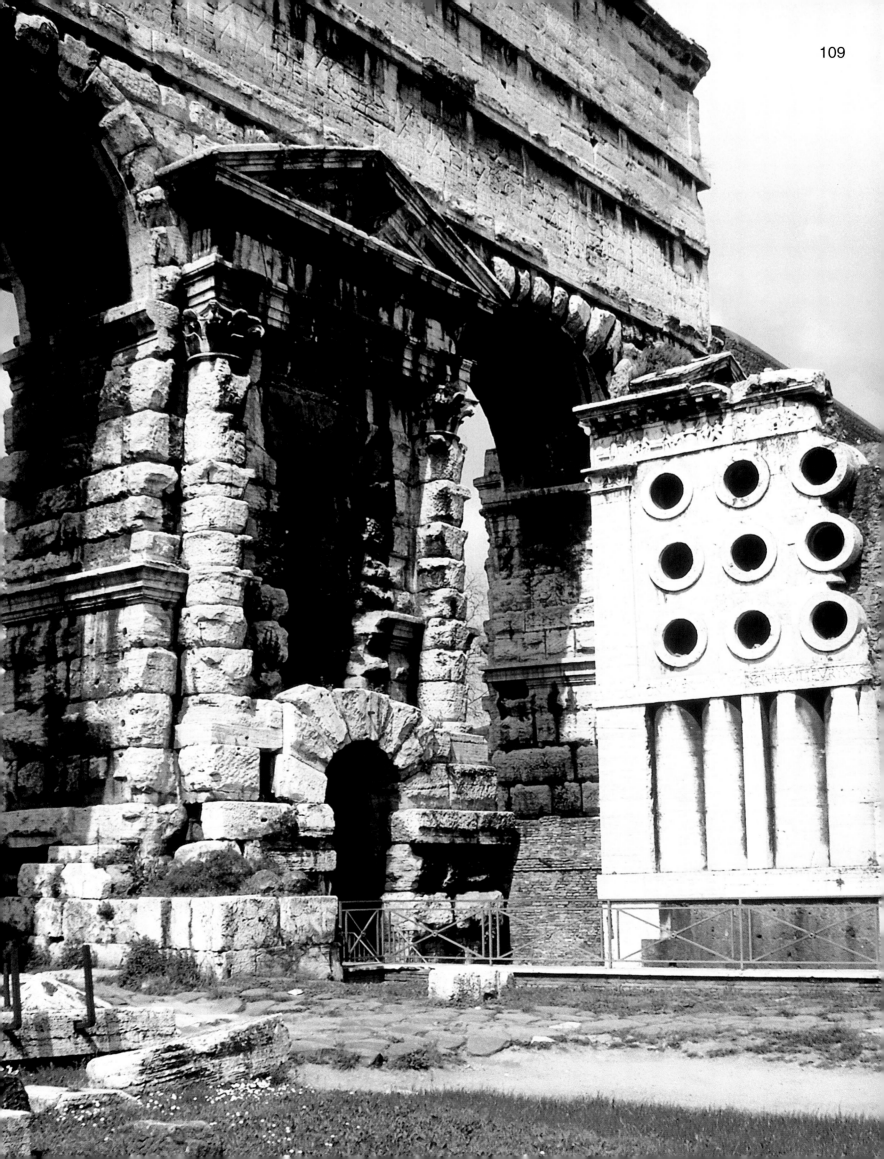

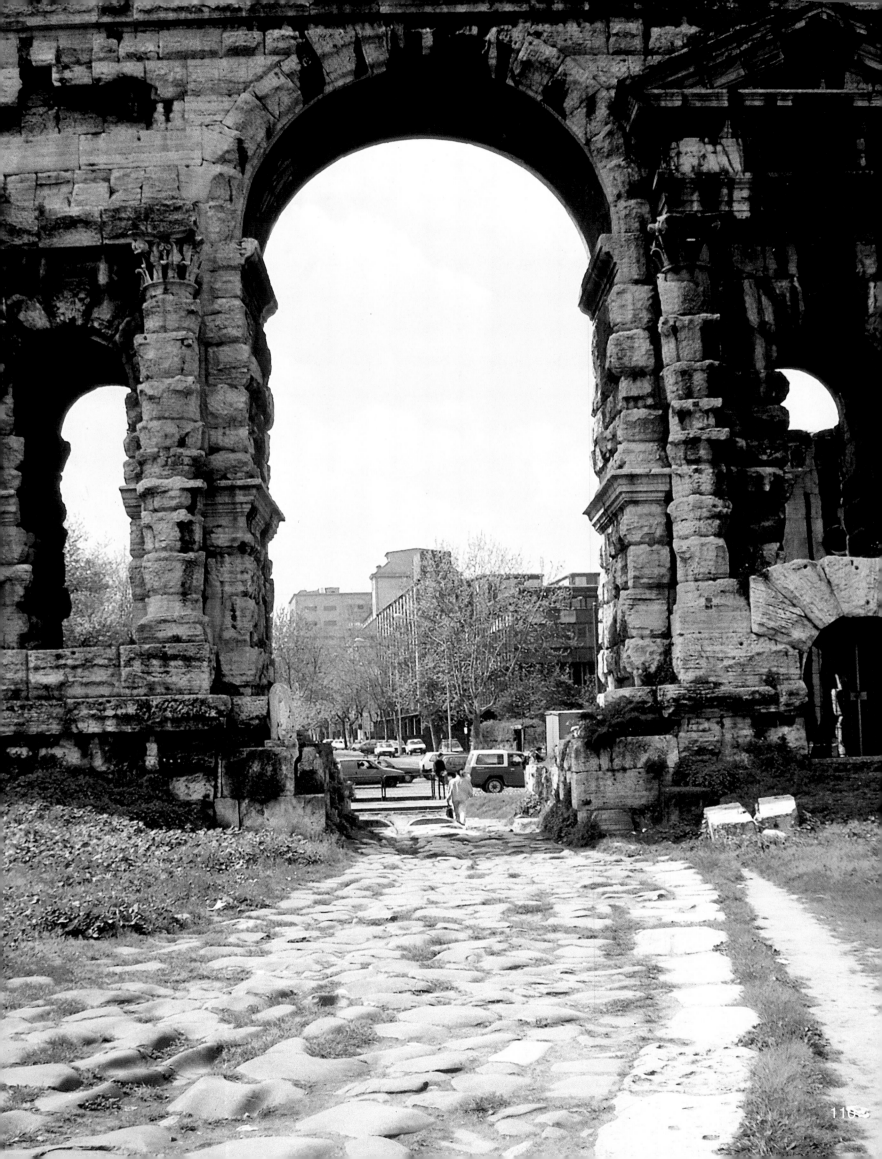

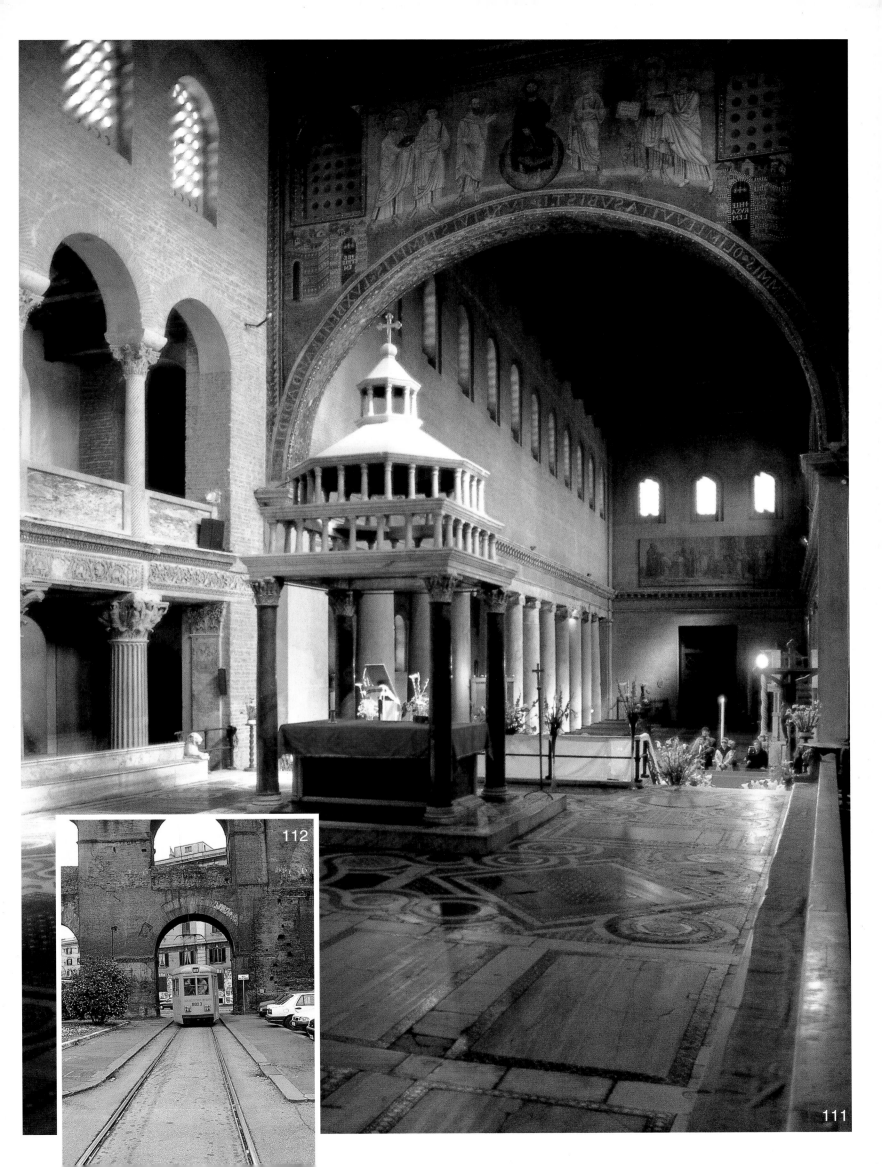

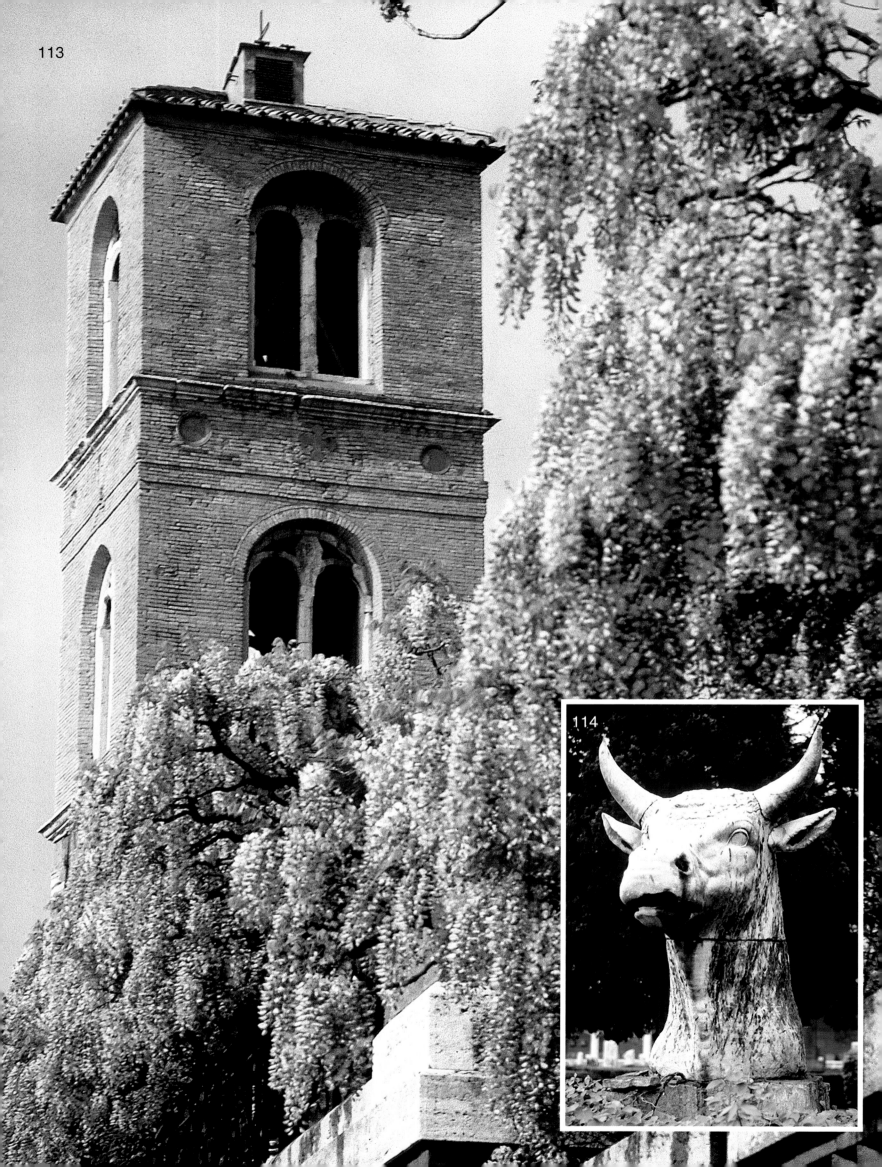

113

114

The Baths of Diocletian

From the Piazza Esquilino, we take the Via Cavour to the Stazione Termini, an impressive construction built in 1937 for the EUR (Esposizione Universale di Roma). Opposite the station are the remains of the Baths of Diocletian, begun in AD 298 and completed in 305–306. This is one of the largest and most magnificent architectural ensembles in Rome. The baths were capable of accommodating some 3,000 people, the style being inspired by that used by Apollodore de Damas for Trajan's Baths. The church of Santa Maria degli Angeli and the Roman National Museum were subsequently incorporated into this ensemble.

115

The Museo Nazionale Romano

The Museo Nazionale Romano, one of the most important in the field of archaeology, was inaugurated in 1889. It houses many precious items illustrating significant periods of artistic culture from ancient Rome to the imperial era. In this century, it has been enriched by antiquities from the Museo Kircheriano and the Ludovisi collection, acquired in 1901.

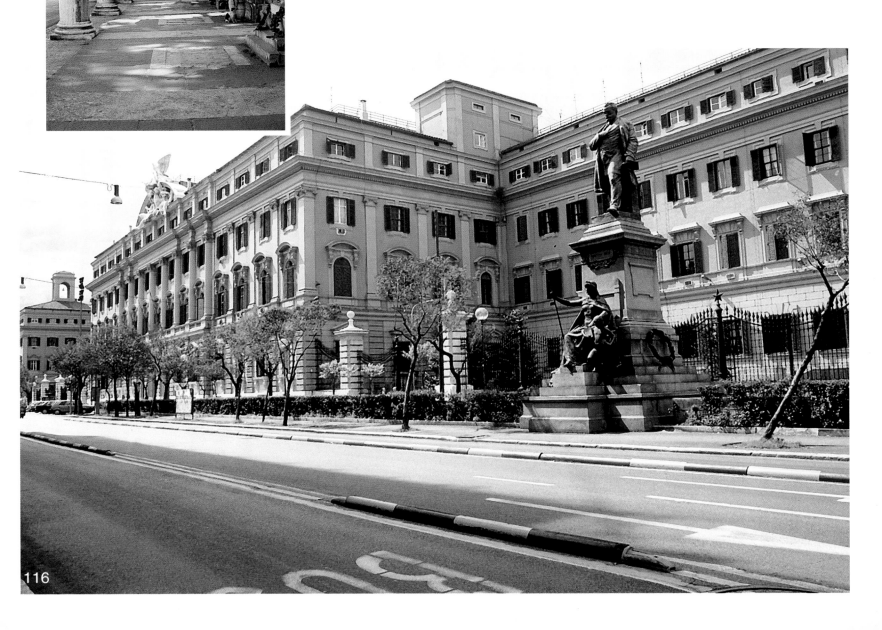

116

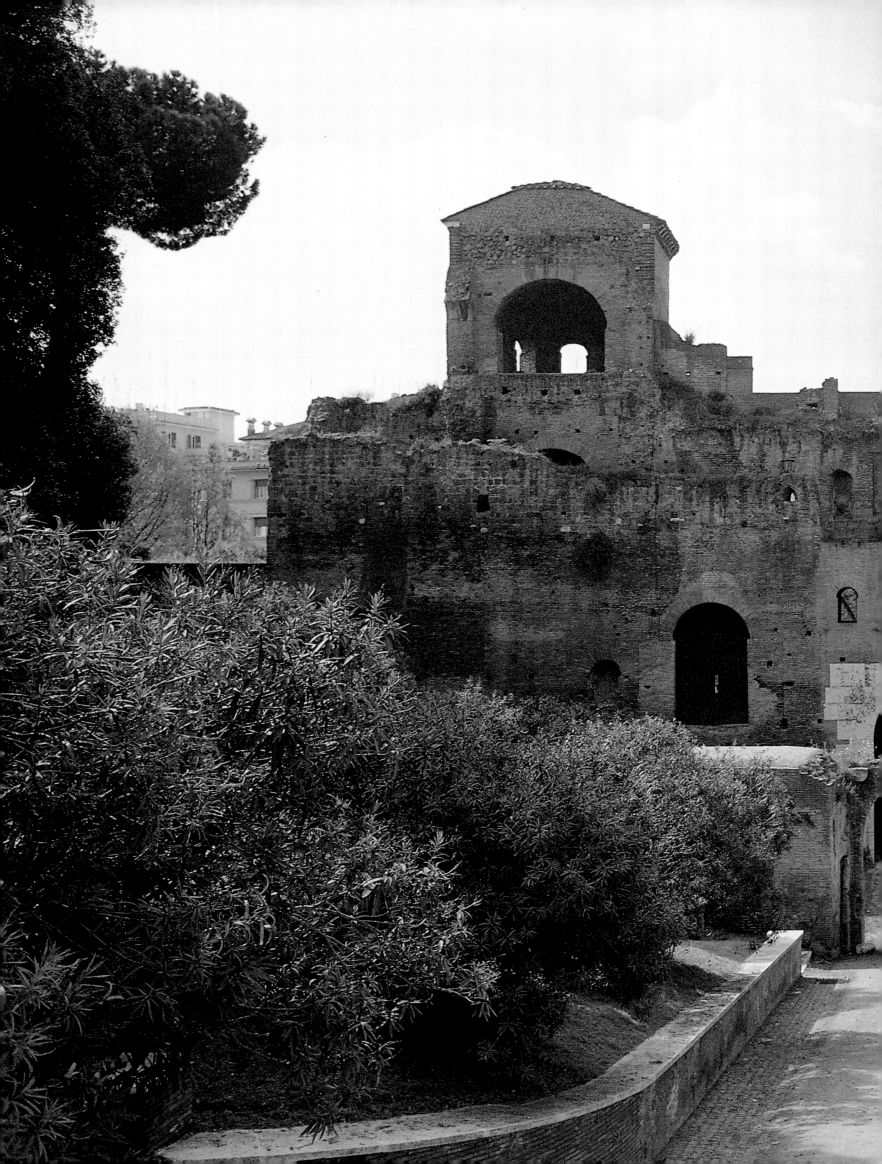

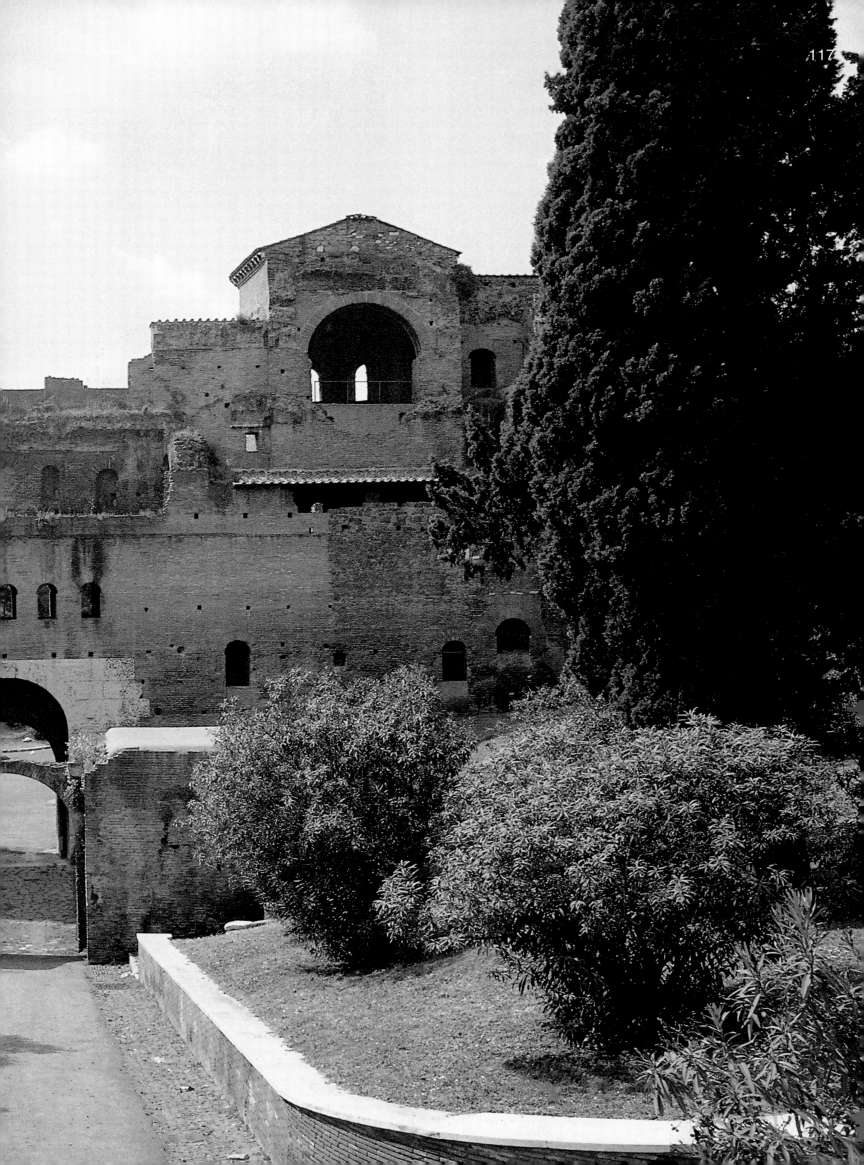

Piazza Barberini, Via Vittorio Veneto, Villa Borghèse, Villa Giulia

Walking along the Via delle Terme di Diocleziano, we come to the Piazza della Repubblica. Here we take the Via Torino, which ends at the Piazza San Bernardo. We cross the Via XX Settembre to reach the Largo di Santa Susanna, and then take the Via Barberini to the Piazza Barberini, a square in the Baroque style. Arriving in the square, we are immediately struck by the

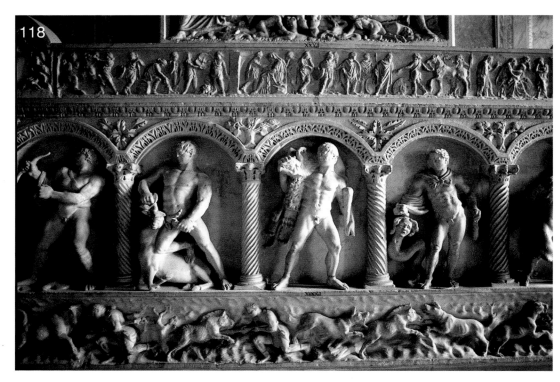

famous and magnificent fountain of the Triton, restored in 1986–87. This is a product of the genius of Bernini, commissioned by Pope Urban VIII in 1642–1643. It depicts a Triton spurting water towards the sky, and is surrounded by allegorical and anthropomorphic motifs. This celebrated fountain features one of Bernini's famous bees, poised on the hinge of the seashell, which recalls those on the imposing baldachin of St Peter's Basilica.

We leave the Piazza Barberini by the Via Veneto: this is the original name of the street, which was rechristened Via Vittorio Veneto after the Italian victory in the First World War. It was officially opened between 1886 and 1889, and became famous for its cafés, restaurants and luxury hotels. From the point of view of town planning, the Via Veneto is one of the most successful streets in modern Rome. There are neo-Baroque buildings alongside others in the fascist style, such as the Ambasciatori Hotel, which marks the passage from Art Deco to the monumental style of the turn of the century. The hotel was built by Marcello Piacentini – one of the designers of the architectural ensemble of the EUR – between 1924 and 1926. The Via Veneto was also made famous by Federico Fellini's film *La Dolce Vita*.

Beyond the Largo Federico Fellini, after the Porta Pinciana, we find the grandiose Villa Borghese beside the Piazza Sienkiewicz. This is an important

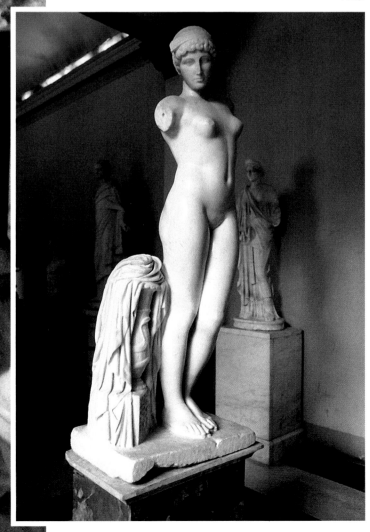

118, 119. *Villa Borghese Museum*
120. *Conservatory Museum – Venere Esquilina*

120

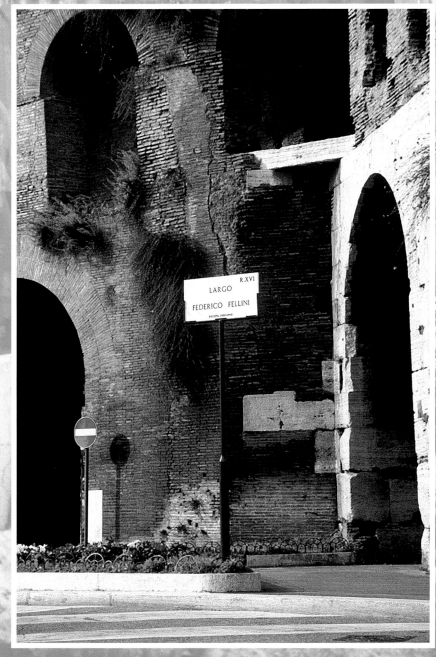

public park containing busts of famous personages. In 1608, Scipion Caffarelli Borghese – the nephew of Pope Paul V – commissioned the architect Flaminio Ponzio to build a villa for use as a museum. Numerous architects were involved in the execution of this project, which was finally completed by Girolamo Rainaldi (1570–1655). The building was enlarged in 1822, with the works entrusted to Luigi Canina (1795–1856). Finally, in 1901 it was sold to the State, which in turn donated it to the City of Rome two years later. The Borghese Museum and the Borghese Gallery are also well worth a visit. Leaving the Villa Borghese, we pass along the Largo Picasso and the Viale delle Belle Arti to the Villa Giulia. This was built between 1551 and 1555 by Giorgio Vasari, Bartolomeo Ammannati and Jacopo Barozzi Vignola, on the orders of Pope Jules III. Today it houses the beautiful Museo Etrusco, which contains numerous Latin artefacts dating from the Iron Age and the Roman era.

San Giovanni in Laterano

Retracing our steps to the Piazza Esquilino – site of the basilica of Santa Maria Maggiore, of which we have already spoken – we turn on to the Via Merulana. This leads us to the Piazza San Giovanni in Laterano, with its church of the same name. This is one of the city's four great basilicas. Situated not in the centre but on the outskirts of the city, near the Aurelian Wall, it is Rome's cathedral. The Bishop of Rome – i.e. the Pope – comes here only two or three times a year, and entrusts its keeping to his Cardinal Vicar. The basilica was originally dedicated to St. Saviour, who was believed to protect the city of Rome against invasion by the barbarians. Subsequently, in the time of St. Gregory the Great (590–604), it was also dedicated to St. John the Baptist (on account of the presence of the baptistery) and to St. John the Evangelist, who represents the interiority and quietude of the Christian life.

The cathedral of Rome was commissioned by Pope Miltiade and built on the remains of the great barracks of the Equites Singulares.

In March–April 1123, since it was no longer necessary or convenient to hold ecumenical councils in the East, the first Lateran Council took place in this basilica under the pontificate of Calixtus II.

The old basilica of Lateran had five naves. The current church has been comprehensively modified. After the sack of AD 455, it is restored on the orders of St. Leo the Great (440–461). In 896, an earthquake damages

the basilica so badly that in 905 the pontiff, Serge III, is forced to order it to be rebuilt. Later, Nicholas IV (1288–1292) has it ostentatiously ornamented. In 1308, the basilica is disfigured once again by fire, and Clement V sets his heart on its reconstruction, even though his apostolic seat is in Avignon. The works are carried out under Urban V (1362–1370) and Gregory XI (1370–1378), and are supervised by the architect Giovanni di Stefano.

A new and radical transformation is ordered by Innocent X (1644–1655) for the Jubilee of 1650, and Borromini is commissioned to direct the works. The facade of the basilica is further transformed by the Florentine Alessandro Galilei in 1735 on the orders of Clement XII. In 1855, under Leo XII, the apse is extended and renovated. Galilei's facade incorporates a balustrade with fifteen statues, each seven metres tall. The central statue is of Christ, flanked by St. John the Evangelist and St. John the Baptist. The other figures represent the Doctors of the Latin and Greek Churches. The facade bears a proud inscription which might be considered slightly excessive: "*Sacrosancta Lateranensis ecclesia, omnium urbis et orbis ecclesiarum mater et caput*" (Sacrosanct church of Lateran, mother and head of all the churches of the city and the world). The porch is also the work of Alessandro Galilei; it has a vaulted ceiling with lowered coffers, and provides access to the basilica by means of five doors.

123

The Palazzo del Laterano, built by the renowned Fontana en 1586, became the seat of the Vicarship of the Diocese of Rome on the wishes of John XXIII and Paul VI. The Scala Santa – the last vestige of the old papal palace – and the 'Triclinio Leoniano' are a living testament to the unfolding of twenty centuries of civilization, if we take into account the archaeological remains associated with Nero, Constantine and Marcus Aurelius. Finally, let us recall that it was here, in this palace beside the basilica, that the Lateran Treaties were signed on 11 February 1929, giving "Italy to God and God to Italy".

124

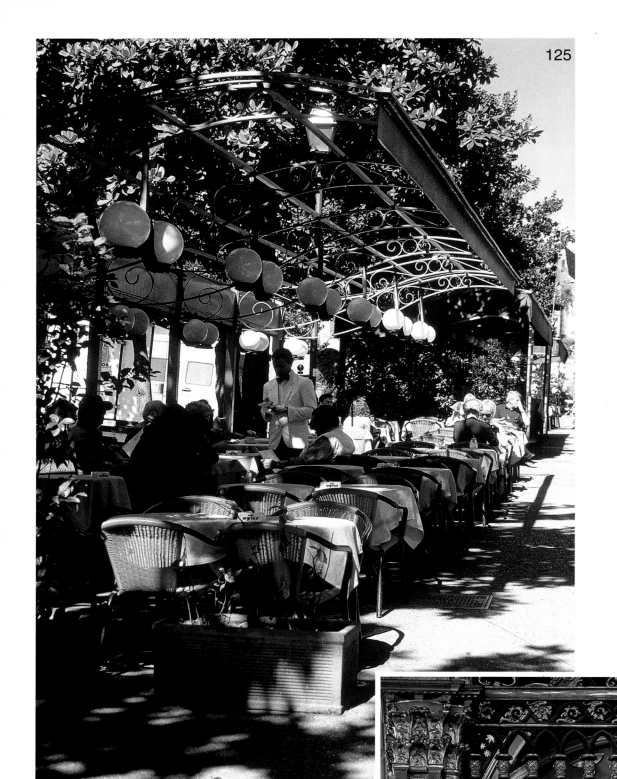

125

Previous page:
121–123. Via Veneto
124. Villa Borghese – police officers

125. Via Veneto
126 et 127. Basilica San Giovanni
in Laterano (basilica of
St. John in Laterano)

126

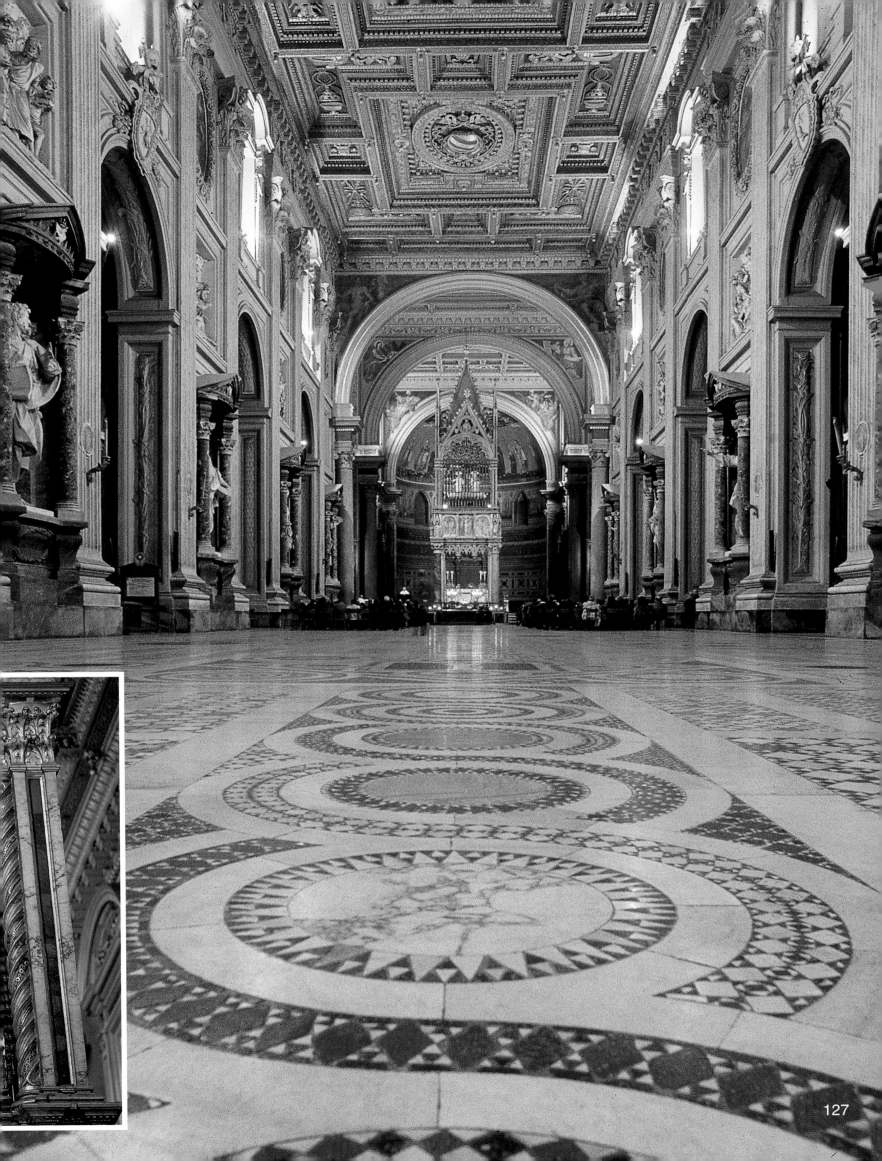

The Baths of Caracalla

From the Piazza San Giovanni in Laterano we take the Via dell'Amba Aradam, and follow this to its end to arrive at the Piazza Porta Metronia. Then we take the Via Druso to the Piazzale Numa Pompilio, where the Viale delle Terme di Caracalla begins. This avenue leads to the 'Largo' of the same name, from which we may enter the baths, a monumental and extremely impressive construction. In their day, the baths could accommodate some 1,600 people. Some of the walls are in an astonishingly good state of conservation. Construction was begun in AD 212 on the orders of the emperor Marcus Aurelius Antoninus, also known as Caracalla, who inaugurated the baths five years later. They were completed by the emperor Heliogabal (who was deposed in a plot) and by his successor Marcus Aurelius Severus Alexander.

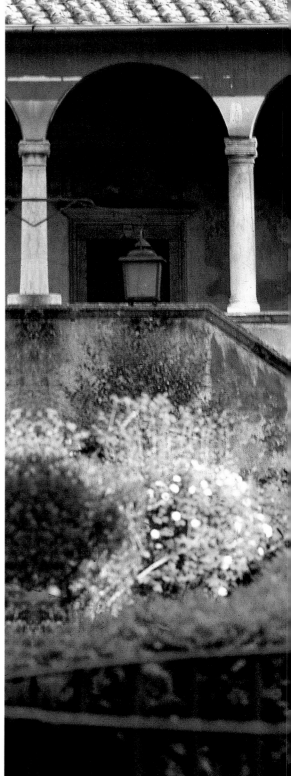

128

129

The Baths of Caracalla were in use until AD 537, when Vitigus, the king of the Visigoths, destroyed the Antonine aqueduct. They comprised the frigidarium, the changing-room, two rooms probably devoted to oils and sand, a 'basilica', two vestibules, the tepidarium, the calidarium, two open rooms for exercises, four service courtyards, two sudation rooms, two gymnasiums, two gymnastics schools, the stadium, two libraries (Greek and Latin), two secondary gymnasiums, two conference rooms, two depositories for oils and perfumes, the great hall, a porch, the cistern and the aqueduct.

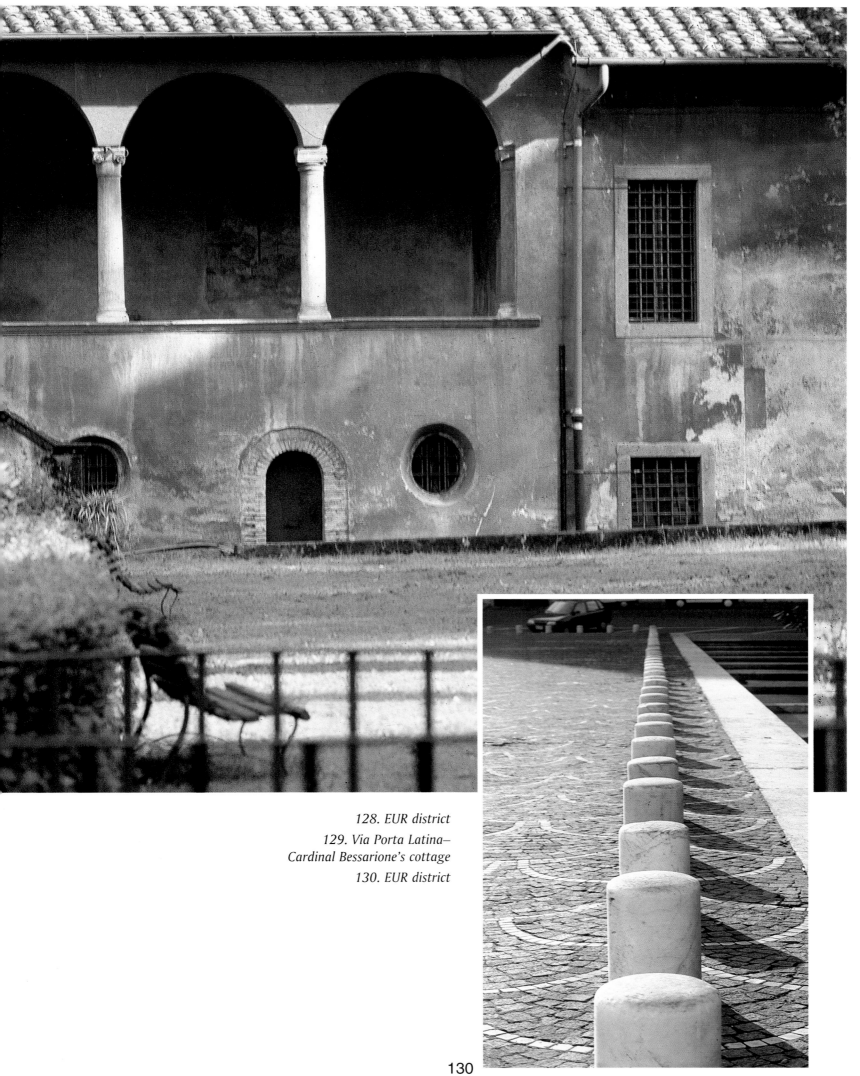

128. EUR district
129. Via Porta Latina–
Cardinal Bessarione's cottage
130. EUR district

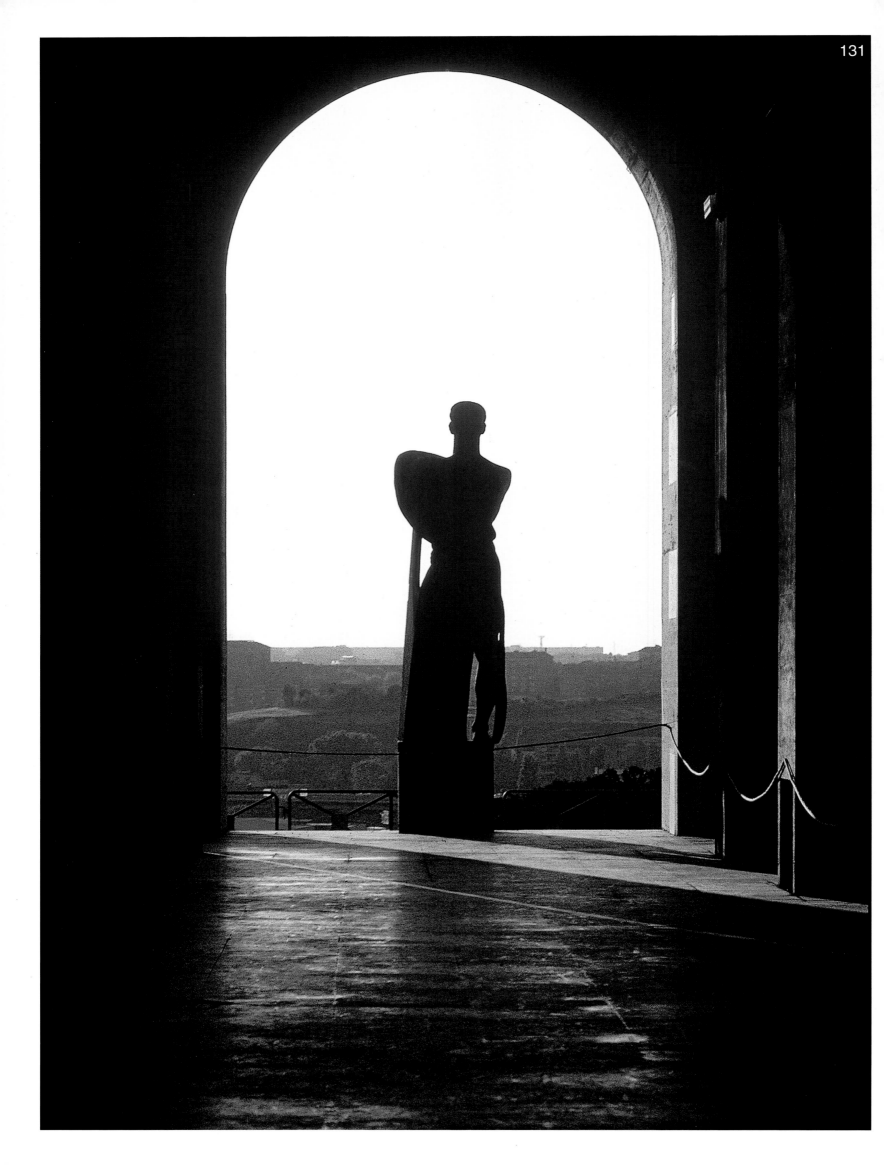

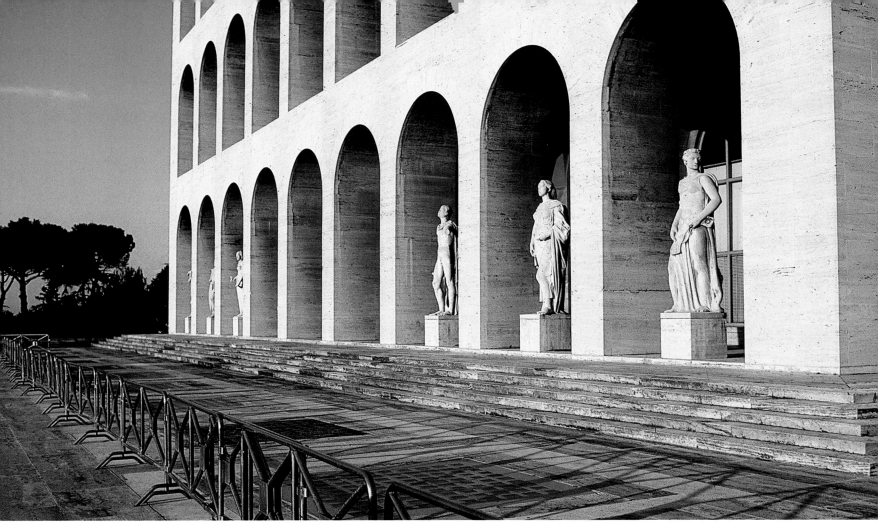

The EUR district

Behind the Baths of Caracalla, we take the Via Cristoforo Colombo to reach the EUR district. From the balcony of the Palazzo Venezia in 1936, 'Il Duce' declared his intention to build a new quarter for the city when he proclaimed the renaissance of the Empire. The new architectural ensemble was also destined to celebrate twenty years of fascist rule.

The original plans were drawn up in 1937 by the architects Giuseppe Pagano, Luigi Piccinato, Luigi Vialetti, Ettore Rossi and Marcello Piacentini. They drew their inspiration from the classical town planning model of the Roman era. An initial scheme was succeeded by a second, headed by Piacentini with the assistance of Gaetano Minnucci, then director of the Department of Architecture. This second plan markedly accentuated the classical, monumental vision. Works were begun in 1939, and continued without interruption until 1942. In 1960, for the occasion of the Olympic Games, the quarter was endowed with sports buildings and facilities such as the Velodrome, the Sports Palace, the Piscina delle Rose, the lake, and the vast architectural ensemble of the Tre Fontane. However, the modern visitor immediately notices the difference between the pre-war and post-war structures; the latter are clearly characterised by those features known collectively as the 'International Style': massive, glazed structures and elementary geometric forms.

131, 132. EUR district

Next page:
133. Galeno House
134. Coppede district
135. Oppio Vincoli

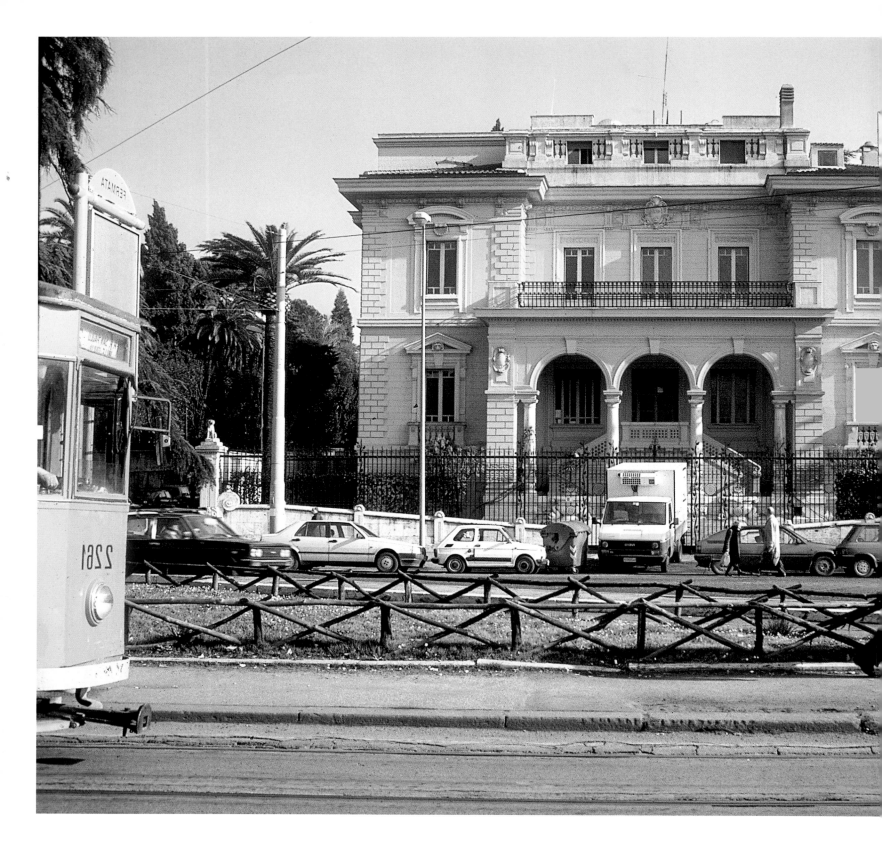

Publishing director
Jean-Paul Manzo

Text
Jean-Paul Manzo and Luciano Ferrari

Layout
Bastien Lelièvre, Parkstone Press

Typesetting
Karin Erskine

Photograph credits
Andrea Luppi

133

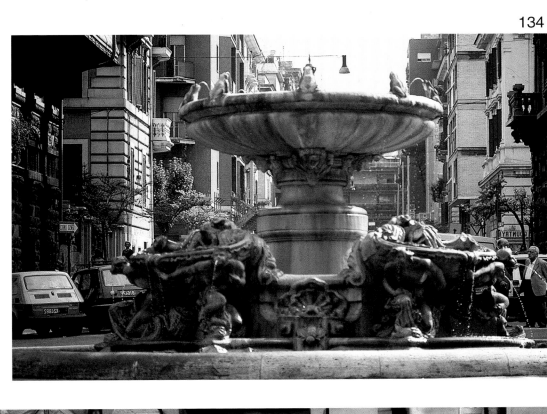

134

135

Parkstone Press Ltd
Printed and bound in Europe
ISBN 1 85995 550 9

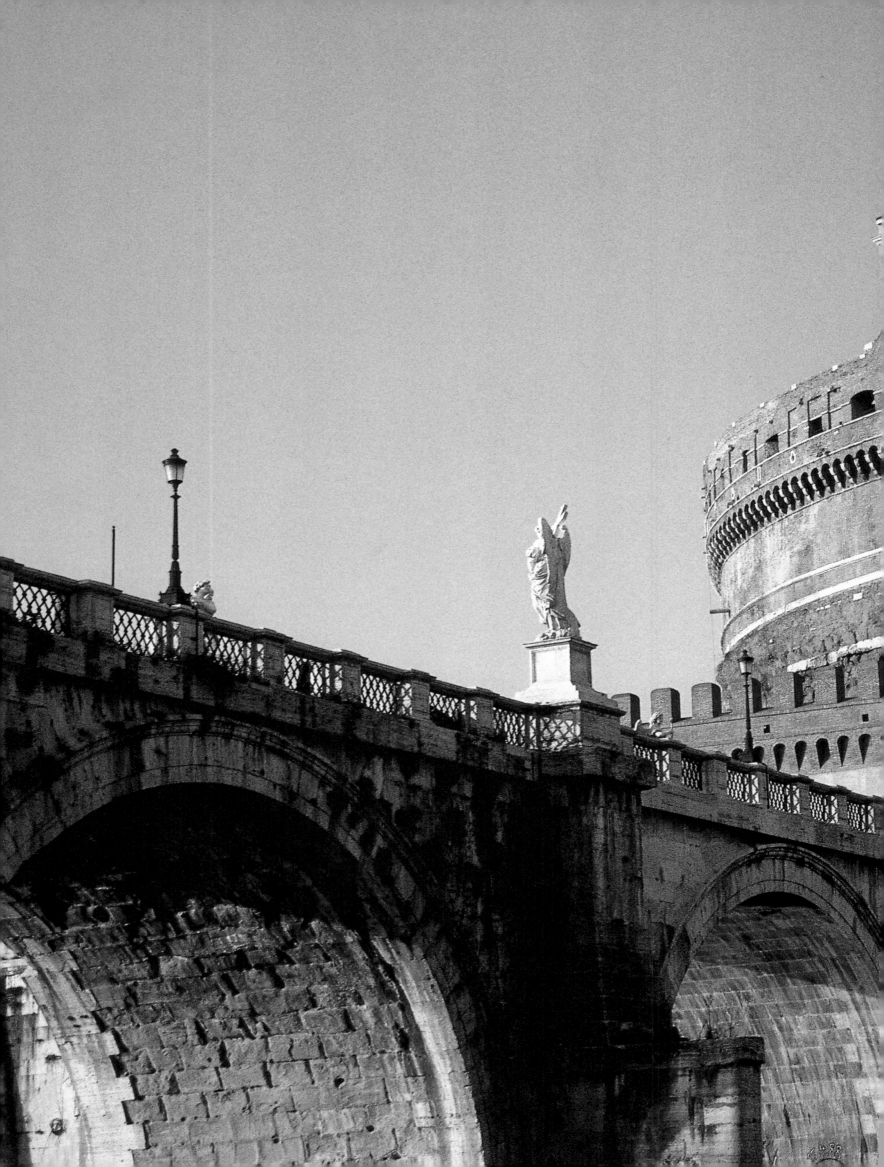